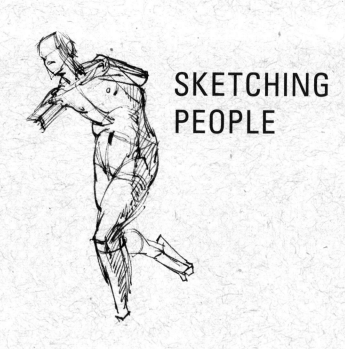

SKETCHING
PEOPLE

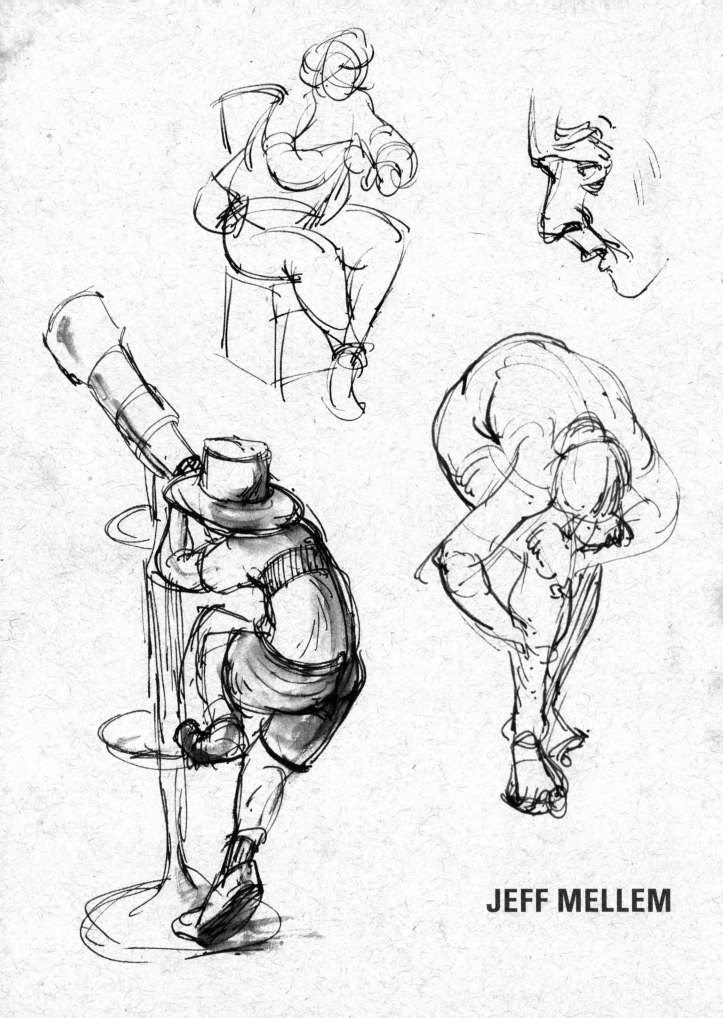

JEFF MELLEM

SKETCHING PEOPLE

LIFE DRAWING BASICS

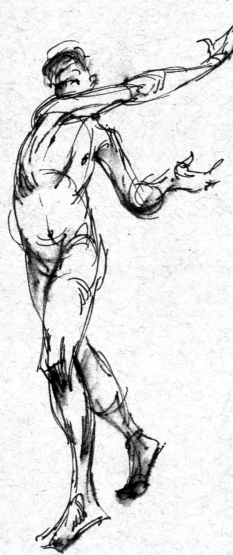

NORTH LIGHT BOOKS
CINCINNATI, OHIO
WWW.ARTISTNETWORK.COM

SKETCHING PEOPLE: LIFE DRAWING BASICS. Copyright © 2009 by Jeff Mellem. Manufactured in U.S.A. All rights reserved. No part of this book may be reproduced in any form or by any electronic or mechanical means including information storage and retrieval systems without permission in writing from the publisher, except by a reviewer who may quote brief passages in a review. Published by North Light Books, an imprint of F+W Media, Inc., 4700 East Galbraith Road, Cincinnati, Ohio, 45236. (800) 289-0963. First Edition.

Other fine North Light Books are available from your local bookstore, art supply store or online supplier. Visit **www.fwmedia.com.**

16 15 14 13 12 8 7 6 5 4

DISTRIBUTED IN CANADA BY FRASER DIRECT
100 Armstrong Avenue
Georgetown, ON, Canada L7G 5S4
Tel: (905) 877-4411

DISTRIBUTED IN THE U.K. AND EUROPE BY DAVID & CHARLES
Brunel House, Newton Abbot, Devon, TQ12 4PU, England
Tel: (+44) 1626 323200, Fax: (+44) 1626 323319
Email: postmaster@davidandcharles.co.uk

DISTRIBUTED IN AUSTRALIA BY CAPRICORN LINK
P.O. Box 704, S. Windsor NSW, 2756 Australia
Tel: (02) 4577-3555

Library of Congress Cataloging in Publication Data
Mellem, Jeff,
 Sketching people : life drawing basics / Jeff Mellem. -- 1st ed.
 p. cm.
 Includes index.
 ISBN 978-1-60061-150-6 (pbk. : alk. paper)
 1. Human figure in art. 2. Figure drawing--Technique. I. Title. II. Title:
Life drawing basics.
 NC765.M46 2009
 743.4--dc22 2009000463

EDITED BY **MONA MICHAEL**
DESIGNED BY **JENNIFER HOFFMAN**
PRODUCTION COORDINATED BY **MATT WAGNER**

ABOUT THE AUTHOR

Jeff Mellem is a professional artist and graphic designer who's worked in many industries over the last decade. Among others, he has designed for magazines, video games and theater. He earned a Bachelor of Fine Arts degree from California State University, Fullerton, and studied drawing at the American Animation Institute in Hollywood, California. Using traditional drawing techniques to create character and story is the foundation for Jeff's work. For more on his work, visit www.jeffmellem.com.

METRIC CONVERSION CHART

TO CONVERT	TO	MULTIPLY BY
Inches	Centimeters	2.54
Centimeters	Inches	0.4
Feet	Centimeters	30.5
Centimeters	Feet	0.03
Yards	Meters	0.9
Meters	Yards	1.1

ACKNOWLEDGMENTS

I'd like to thank my family for their support while I worked on this book. To my parents, Glenn and April, thank you for valuing education and supporting me in my pursuits. To my brother Danny, thank you for all your brilliant advice and your friendship. To my brother Eric, thank you for always making me laugh and sharing my interest in great stories.

I'd also like to thank the whole Aylard family, particularly Todd and Jill, whose love of art and ideas I've always found refreshing.

Thank you to my friends at National Dragster, who have been helpful and encouraging through the process of developing this book. A special thank-you to Matt Hurd, who helped me with his knowledge of print, and Lorraine Vestal, who copyedited an early version of the book.

A very special thank-you to my teachers, who gave me a solid foundation in art. Thank you, Don Lagerberg at Cal State Fullerton, for teaching how art can tell a story. Thank you, Glenn Vilppu, for teaching the true fundamentals of art.

I'd like to thank North Light Books for taking on this project.

Finally, I'd like to acknowledge the artists whose work greatly impacted me: Michelangelo, Daumier, Heinrich Kley, Bill Watterson, Chuck Jones, and all the great artists who create life out of lines on a page.

"My hope is that by learning the essential principles of drawing you will be free to express your life through your art."
—Jeff Mellem

CONTENTS

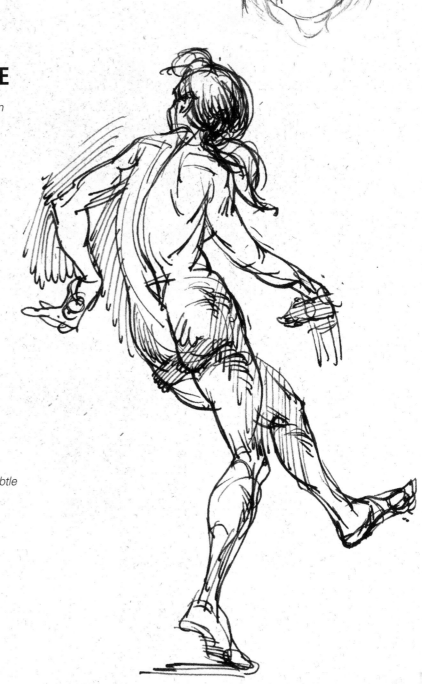

Chapter Five

When we look at another person, we usually look first at his or her face. Not only is it how we identify that person, but it is also how we try to determine whether he or she is angry, sad, elated, disgusted or mischievous. It will show in facial expressions.

Chapter Six

Drawings begin to take on a life of their own when a figure begins to act out emotions.

Chapter Seven

For a visual artist, choosing how to depict an event—what parts are emphasized and what are downplayed, the angle the scene is depicted from, how close the viewer is brought to the action—is done through staging.

Chapter Eight

Light's vibrant energy is what creates the subtle shades on a form for our eyes to see.

INTRODUCTION

Every artist dreams of sitting in a café, opening a sketchbook and being able to capture the characters and beauty we experience in everyday life. For the visual artist, a sketchbook can become a personal journal that not only depicts his or her experiences but also is a private place to produce new ideas and develop technical skill. Unfortunately, sketchbook drawing can be a frustrating experience without a logical procedure for capturing a world that is constantly in motion.

While practicing drawing in an art studio has the advantage of a controlled environment, giving the artist the ability to rein in the subject to his or her desire, drawing from life requires a more reflexive approach to quickly capture and interpret the real world. It requires a spontaneity that only comes from an ingrained mastery of fundamental drawing skills.

The sketchbook is a perfect medium to improve your drawing ability because its portability allows you to draw anywhere and at any time with interesting subjects everywhere you are. The basic principles of drawing are the same no matter where you're working. Principles of line, form, shade, color and composition don't change. However, because you don't have control over your subjects outside of the studio environment, you will have to sharpen certain skills that are otherwise easily downplayed. For example, you cannot dictate how long a couple in an airport holds an embrace, and you'll have to capture their gesture very quickly or from memory. In contrast, while working from a model or a photograph, you might be tempted to skip the critical gesture phase and jump straight to copying contours and shapes. Drawing from life sharpens your skill because it requires a true understanding of the fundamentals of drawing.

Keeping a sketchbook is also fun. You are free to follow your whims to explore where they may lead. However, drawing can be frustrating at times when pushing the limits of your abilities. There will be days when you feel that not one single drawing was worthwhile and your growth has come to a halt. Be aware that as you tackle more difficult concepts, the incubation stage between acquiring a piece of knowledge and making it ingrained through practice grows longer. Hitting a plateau in your growth is a time of integrating new ideas, not a dead space between growth spurts. Rest assured that under the pressure of consistent practice, the difficulty will eventually disappear. If you do begin to lose your motivation while attempting something challenging, remember that simple subjects can be rewarding, too.

Draw for at least thirty minutes every day. By practicing every day your mind will become more accustomed to solving those types of problems. Just be sure to have fun. Play around with ideas and techniques to make them your own. Just because you're acquiring new skills doesn't mean it has to be a serious endeavor. I am constantly laughing or otherwise reacting at the sometimes unexpected final results of a drawing—an unintended juxtaposition, an expression that really captures a character's attitude or a drawing that just went south. The emotion you have about drawing will come across in your work.

Ultimately, a sketchbook is a private workbook. It is a home for unrefined ideas and vignettes from your experiences. Some drawings may never develop beyond a few initial gesture lines, and may not need to because you've conveyed the subject's essence or the drawing has inspired a new thought. The important part is to capture whatever interests you, be it a person's body language, a certain mood or a skill you're practicing. In that way, each drawing is intentional, attempting to achieve a specific effect, yet still you're not concerned with creating a finished piece for public display. This allows you to approach sketchbook drawing with a freshness and without fear because there is not an expectation that every drawing has to look "good."

Initially, drawing in public may cause you a great deal of anxiety because people will look at you as a performance artist. They will look over your shoulder as you are drawing and even make comments (though usually supportive). This is something you'll just have to get used to. Some of the best places to draw are those where groups come together to have fun, like malls, zoos, fairs, etc., and while you're there to draw, they will see you as part of the entertainment. They aren't judging you; they're just enjoying seeing you work.

One time, when I had first started venturing out of the studio with my sketchbook, I suddenly found myself surrounded by fifty or more young schoolchildren who came to the zoo on a field trip.

You can try to hide in some private niche, but I guarantee someone will find you. You will be much better off choosing a spot so you can best observe your subject than picking it for its privacy. The faster you put yourself out there, the quicker you will become accustomed to being observed by the very subjects you are observing.

SKETCHING MATERIALS

Your choice of materials will also affect how you feel about the sketching experience. Your materials need to be portable so that when you're out walking around looking for a spot to draw they will be easy to use when you need them. If you feel you have to lug around lots of media, you will be less inclined to go out and draw. A simple sketchbook and some kind of drawing implement, like a pencil or pen, is all you really need.

Your materials don't need to be expensive or elaborate. You can go to a paper store and buy a few reams of different kinds of paper and have them wire- or comb-bound at a photocopy center. This allows you to choose different colors and textures of paper rather than being stuck with all white pages as in most sketchbooks you can buy off the shelf; it's also far less expensive. With a little additional work you can cut sheets in half and have them bound to make an even more portable sketchbook. If you like making your own sketchbooks you can invest in your own binding system so you can make them at home.

Pencils and ink pens are easily carried around in a pocket and are great materials for sketching. A fountain pen is an excellent tool for sketching, not only because it's easily portable, but also because the flexible nib allows you to draw different widths of line depending on the pressure you apply. The pen has an ink reservoir that will last you all day and is easily refillable. Fountain pen ink is available in a wide variety of colors, and because fountain pen ink is water-soluble, you can create an ink wash just by applying water from a brush to your drawing.

It's important to take care of a fountain pen to keep it working properly. Don't let the ink dry out in the pen; if you aren't going to be using it regularly, remove all the ink. Also, only use fountain pen ink. You cannot use India ink, drawing inks, watercolors or anything else or you will destroy your pen. Although skill is more important than the materials you are using and I don't usually like to mention specific brands, fountain pens are expensive, and it can be time-consuming to find the right fit. I personally like the line and flexibility of Namiki's Falcon fine-point fountain pen, though I have also had a good experience with Parker's Sonnet pens. By far, my favorite ink is made by a small company named Noodler's Ink.

MATERIALS FOR COLOR

I find watercolor to be the easiest medium for portability. A small watercolor travel kit is all you really need. Again, you can save money if you make your own by using a small candy tin, gluing in some small cups and filling them with watercolors from a tube. You will also need a quality travel brush, a small container of water and a cloth or a couple of paper towels to wipe off the brush. Although this may seem like a lot of materials to carry, it is far easier than trying to carry an array of colored pencils, markers or paints and a pallet. To pare down even more, there are inexpensive brushes that have a water reservoir built into the flexible plastic handle, eliminating the need for a separate water container. Although these brushes are of lesser quality, it is more than sufficient to apply simple areas of color or add a wash to a fountain pen drawing.

I try to carry all my materials around in a pocket where they are readily accessible. If you have to rummage through a bag to find what you're looking for, you will be less inclined to use it. You'd be better off bringing along fewer tools than to have several that you never use.

HOW TO USE THIS BOOK

This book is designed to help you learn traditional drawing principles and how to apply them to sketching. Each chapter builds from the previous chapters, so I'd advise you to start from the beginning and move through sequentially. The techniques found in this book are so fundamental that even if you are an excellent draftsman already, I believe you will still find the lessons useful. My hope is that by learning the essential principles of drawing you will be free to express your life through your art.

OBSERVATIONAL DRAWING

All drawing begins with careful observation. Whether you are looking at a subject's contours, a person's clothing, someone's body language or studying anatomy, what you see comes before what you draw. That isn't to say that you are limited to only drawing what you see, but because art is a visual medium, everything relates back to what can be seen. Even abstract art that is completely nonrepresentational relates to the world in color harmonies, contrast or texture, but it all begins with the artist's observations.

The challenge of representational drawing is being able to translate a three-dimensional object onto a flat surface and make it seem real. It's quite amazing that lines on a page can create the illusion of depth, but by re-creating the values, edges and size relationships as they are seen, the mind will perceive space where it doesn't exist.

Whether you are drawing from a model or sketching in public, keen observation is a vital skill to possess, and is the basis for all representational drawing. Eventually, your observational skills will be applied to analyzing how something is put together, and while you will be building your drawing in a different way, the tools in this chapter help lay the foundation to unlock these additional techniques.

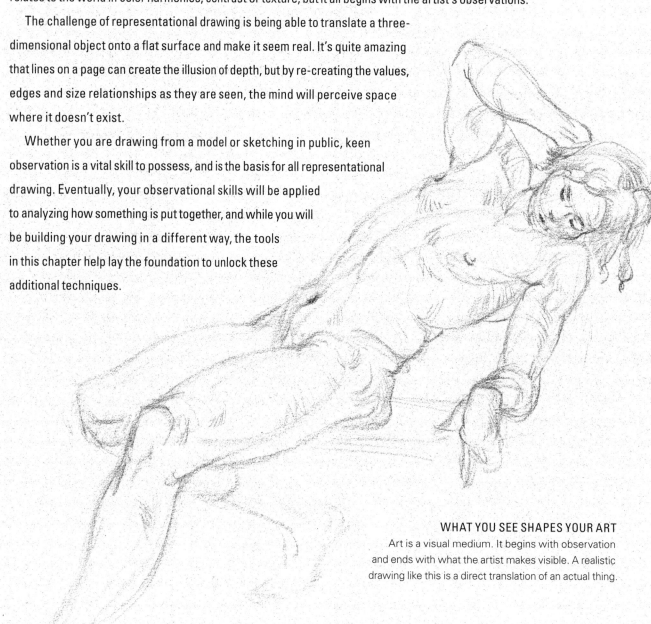

WHAT YOU SEE SHAPES YOUR ART
Art is a visual medium. It begins with observation and ends with what the artist makes visible. A realistic drawing like this is a direct translation of an actual thing.

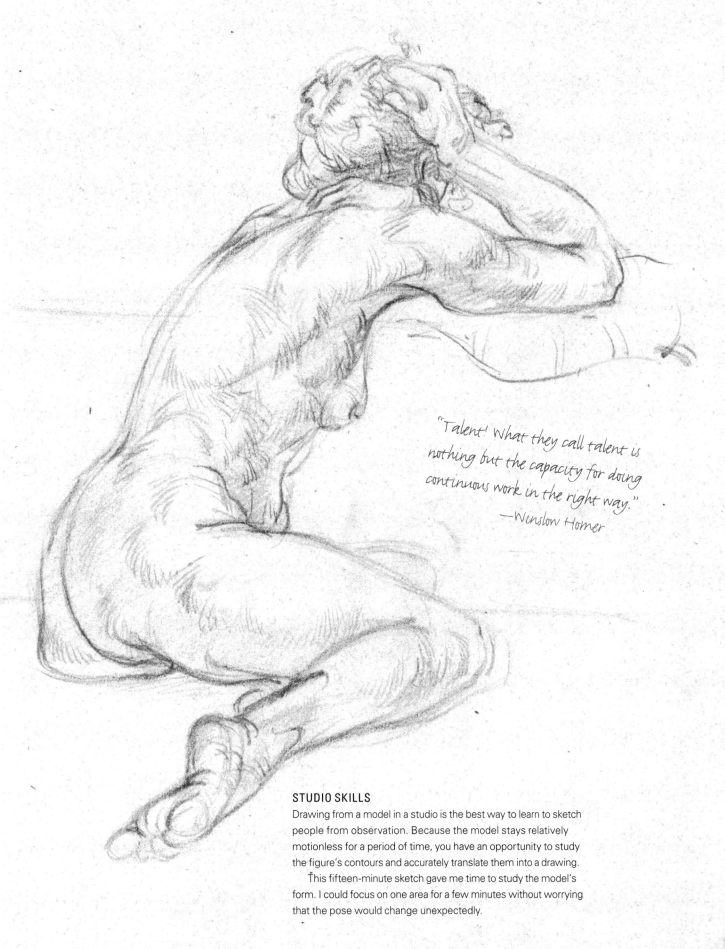

"Talent! What they call talent is nothing but the capacity for doing continuous work in the right way."
—Winslow Homer

STUDIO SKILLS

Drawing from a model in a studio is the best way to learn to sketch people from observation. Because the model stays relatively motionless for a period of time, you have an opportunity to study the figure's contours and accurately translate them into a drawing.

This fifteen-minute sketch gave me time to study the model's form. I could focus on one area for a few minutes without worrying that the pose would change unexpectedly.

POINT-TO-POINT

Point-to-point is an excellent method for exactly re-creating a subject in a drawing. It allows you to "grow" a picture by starting with one small element and using that as a reference to add additional lines. By plotting where corners and plane changes occur in relation to other lines and objects already established, the drawing will expand from one small part to a complete image.

The key is to look at the subject as if it were two-dimensional. Ignore the fact that you are drawing something you recognize and just draw the contours as you see them. Many people run into trouble when they try to "correct" the drawing by forcing the lines to conform to the way they think it should look instead of how it actually looks. Instead, look at how the contours relate to each other two-dimensionally, taking measurements from parts already established in your drawing. If you don't take the time to measure, you will draw what you think the subject should look like and not how it actually appears.

USING POINT-TO-POINT

When you are drawing something complex, you may be overwhelmed by its many parts at first. Just start with something that has a clear length and width that will establish a unit of measure in the drawing. Then look for other lines that are parallel, that intersect or that align with that edge and continue with them. You may find it helpful to actually place dots on the page where lines begin and end to help you analyze the line's length, angle and how it intersects with what's already established before you draw the line. You can also use the point-to-point technique with loose lines. Resist the temptation to be too rigid.

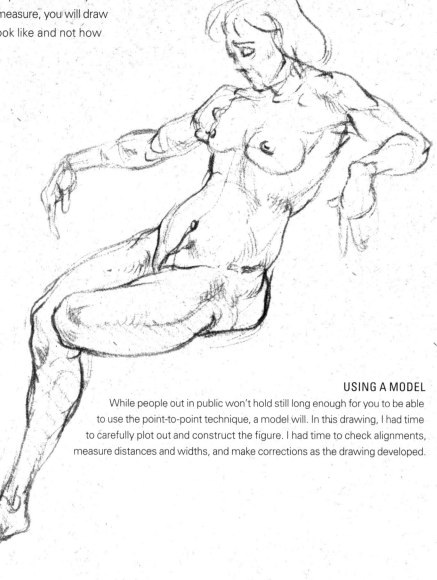

USING A MODEL
While people out in public won't hold still long enough for you to be able to use the point-to-point technique, a model will. In this drawing, I had time to carefully plot out and construct the figure. I had time to check alignments, measure distances and widths, and make corrections as the drawing developed.

SKETCHING POINT-TO-POINT

Point-to-point drawing is a real test of your observational skills. It requires a lot of concentration and analysis, and will help you to strengthen your mental focus. Try the point-to-point method for yourself, either following along with the demonstration or using your own subject.

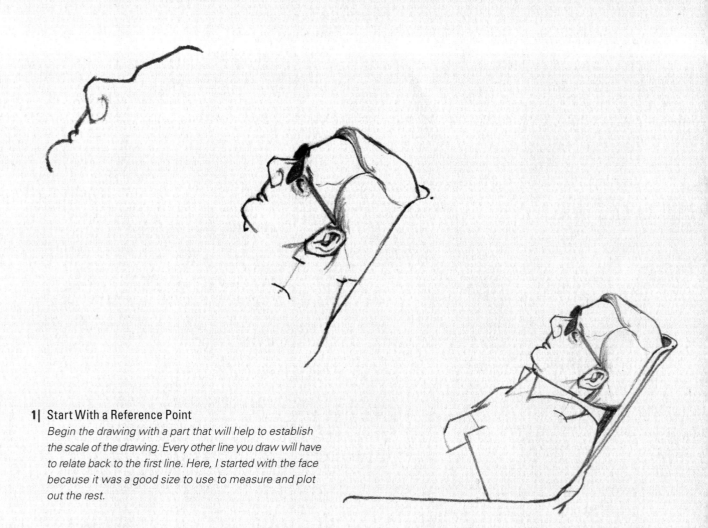

1| Start With a Reference Point

Begin the drawing with a part that will help to establish the scale of the drawing. Every other line you draw will have to relate back to the first line. Here, I started with the face because it was a good size to use to measure and plot out the rest.

2| Build Out From the First Lines

You can now use your first lines as a reference to build out more of the drawing. The length of the face is the same distance from the top of the nose to the back of the chair. You can see a few dots and measure marks that will help as I add more to the drawing.

3| Pay Attention to Angles, Distances and Placement

Each line has three components: length, angle and placement. Measure distances by comparing the length of a part already drawn to a part you are adding. Once you know the length, figure out what angle it is relative to in the lines already established. Finally, make sure the line is placed correctly by looking for alignments and intersections.

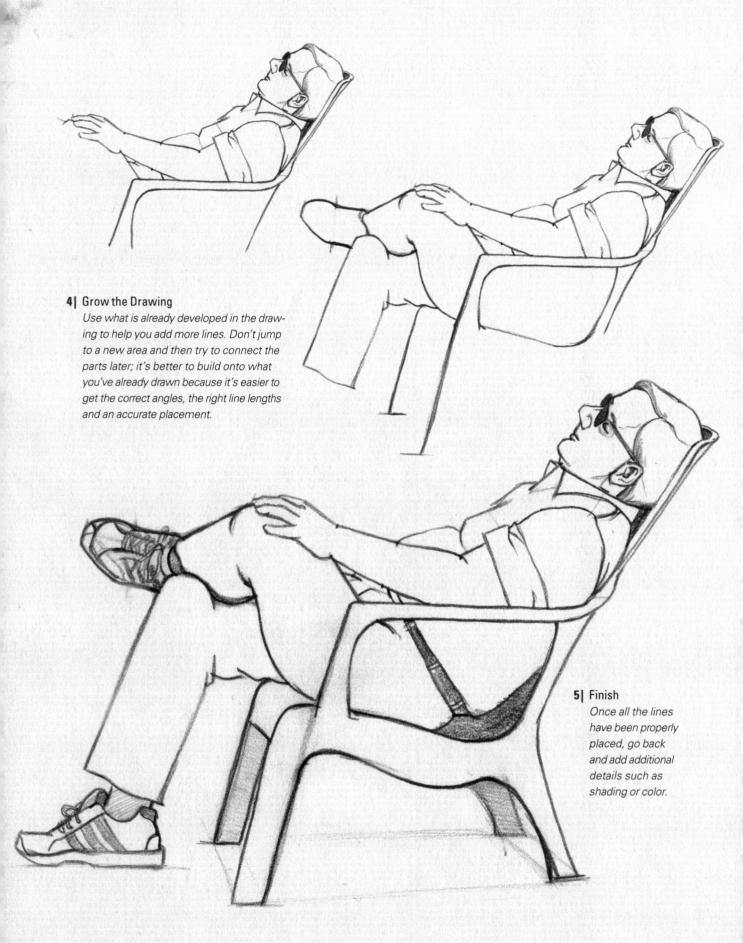

4| Grow the Drawing

Use what is already developed in the drawing to help you add more lines. Don't jump to a new area and then try to connect the parts later; it's better to build onto what you've already drawn because it's easier to get the correct angles, the right line lengths and an accurate placement.

5| Finish

Once all the lines have been properly placed, go back and add additional details such as shading or color.

ALIGNMENTS | POSITIVE & NEGATIVE SHAPES

One problem with only using the point-to-point technique is that any error will be compounded as the drawing progresses. Point-to-point requires you to be extremely accurate in recording and measuring. If something is out of proportion or at the wrong angle, anything that is added that connects with those edges will also be off. To mitigate this problem, use tangents to help you align contours and shapes that don't actually touch.

If you were to actually draw these alignments, as I have on the drawing here, the lines will not only show you how parts line up, but also that the empty area has a distinct formation. These negative areas have a shape and an edge just like the object itself does. It helps to break down the total object into smaller parts and acts as a check to the accuracy of your observational skills. Remember, observational drawing is about translating what you see into shapes, edges and plane changes, so it doesn't matter if you are drawing an object that has volume or the shape of the void that borders the subject.

PLANNING YOUR SKETCH
In this drawing of a statue, the bottom left edge of the shield lines up with the outside of the forearm. The top left angle of the shield roughly lines up with the right side of the face. Of course, these alignments would change from a different vantage point, but they help to plot out the drawing by connecting parts that are not right next to each other.

15

LANDMARKS & PROPORTION: HEAD WIDTH

While it is possible to exactly translate a subject into a drawing through careful observation, a little understanding about the object will help you know what to look for. The more you understand, the better your observations will be. Although people come in all shapes and sizes, everyone's body structure is relatively proportional. A large bodybuilder and a short horse jockey both stand roughly seven and a half heads tall if you use their head height as a measure. The proportion of the muscular man's skeletal structure is the same as the jockey's, it's just larger.

Knowing this, you can plot out landmarks on the body using the point-to-point technique. But first you need to establish a relative unit of measure for your specific subject's body. Many artists use head height to break down the proportion. The problem, however, is that the distances sometimes fall on landmarks that are movable, such as the nipples and the bellybutton, which makes it difficult to measure when the figure is in a dynamic pose and the landmarks have shifted up or down. A better unit of measure is the head width because the intervals fall on bony landmarks (areas where the skeleton is near the surface of the skin) that stay in the same place regardless of pose. The head width is basically the distance between the two ears; it's also called the five-eye line because the width of the head is the distance of five eyes. Just like using the point-to-point technique where you determine a unit of measure from something you've already established in your drawing, the head width measurement will help you consistently place all the landmarks that will help you build the drawing with correct proportions.

FRONT LANDMARKS

Using the width of the head as a measurement, the landmarks on the front of the torso from top to bottom are: the bottom of the nose, the pit of the neck, the bottom of the sternum, the bottom of the rib cage, and the front protuberance of the pelvis. The top of the groin is an additional half unit.

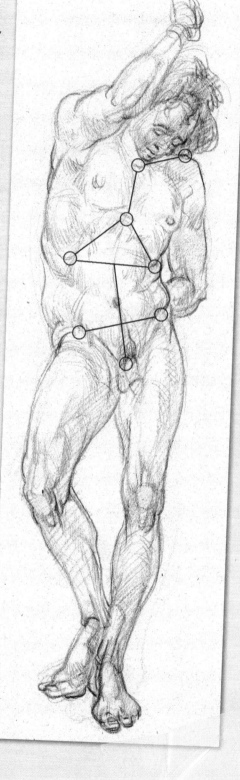

BACK LANDMARKS

The landmarks on the back run down the spine. Though the actual landmarks aren't on the spine, they can be located by drawing a line along the spine. The landmarks along the back are: just below the base of the skull, the top of the scapula, the bottom of the scapula, the base of the rib cage, and the center of the tailbone.

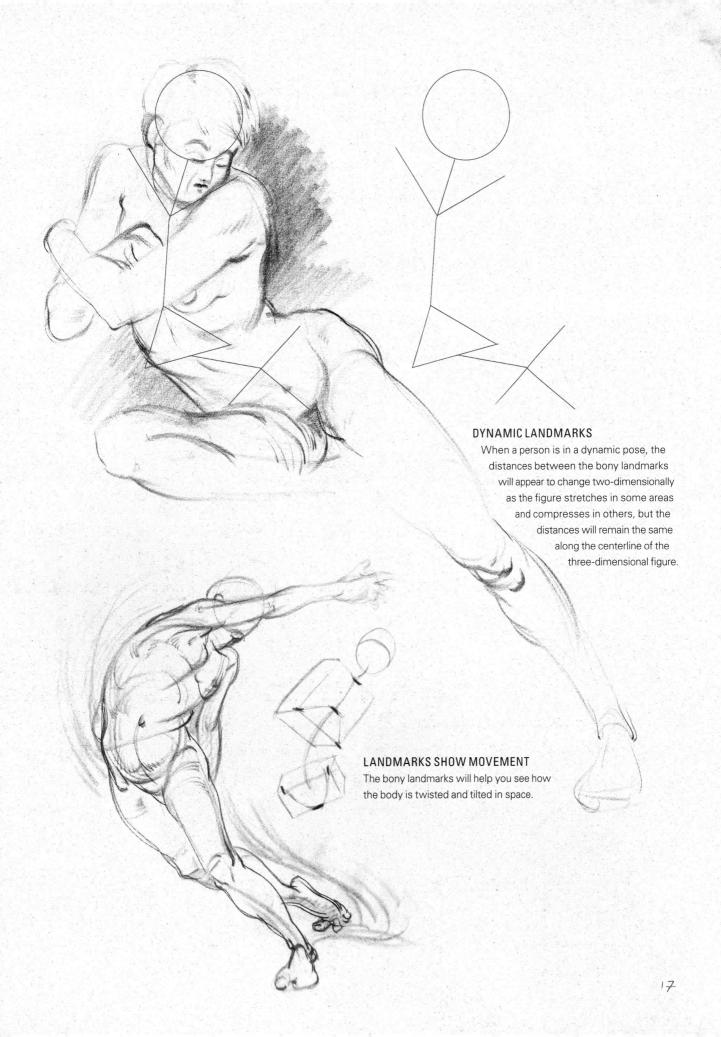

DYNAMIC LANDMARKS
When a person is in a dynamic pose, the distances between the bony landmarks will appear to change two-dimensionally as the figure stretches in some areas and compresses in others, but the distances will remain the same along the centerline of the three-dimensional figure.

LANDMARKS SHOW MOVEMENT
The bony landmarks will help you see how the body is twisted and tilted in space.

17

MUSCLES

Learning the muscles is part of learning to draw the human form. Anatomy books are an important part of educating yourself about anatomy, and I'd suggest you buy a book specifically geared for artists. But even that won't tell you the whole story. Understanding the muscles does not mean memorizing all of their names. Learning the muscles means understanding how the human form is designed. Muscles on a model never look like they do in an anatomy book—they stretch and flex, are foreshortened or twisted and, most importantly, have volume and shape that contort as a person takes a different pose. Use anatomy books to help you identify muscles, to help you understand what you are looking at and what to look for, but use your observational skill coupled with your knowledge to draw the figure. This is the first step in moving beyond copying your observations to re-creating what you have observed. Eventually your observations will give you enough knowledge to allow you to draw what you have seen only in your mind.

THE HUMAN FORM
The muscles are the body's substructure. They are a big part of what gives the figure its shape and form. Understanding what goes on beneath the surface will help you see important details that might have gone otherwise unnoticed.

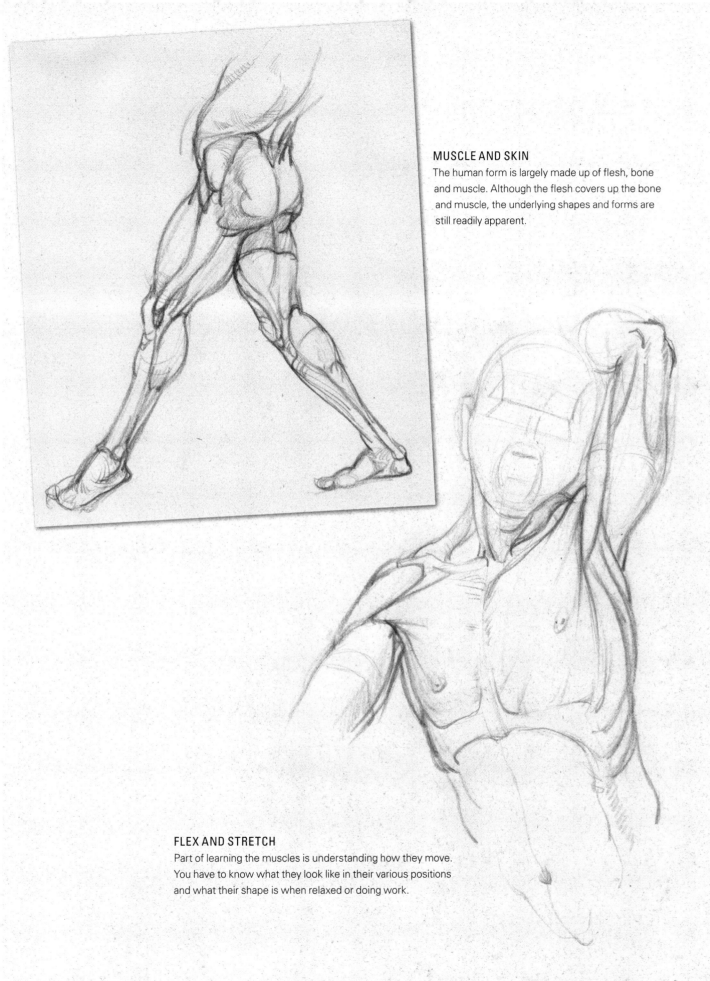

MUSCLE AND SKIN

The human form is largely made up of flesh, bone and muscle. Although the flesh covers up the bone and muscle, the underlying shapes and forms are still readily apparent.

FLEX AND STRETCH

Part of learning the muscles is understanding how they move. You have to know what they look like in their various positions and what their shape is when relaxed or doing work.

Chapter Two

GESTURE

In the last chapter, we explored drawing solely through observation. Maybe you're thinking, "How can I do anything else but draw what I see?" but if you want to be able to draw people on the street who don't stay still long enough for you to record their exact contours, you'll need another tool in your toolbox.

Gesture is the first step in creating drawings from your imagination. Or maybe I should say re-creating because you are attempting to translate what you saw in a moment into a drawing that may take several minutes to develop.

In public settings, subjects rarely stay still for very long. They are constantly gesturing or shifting their weight. If they are doing something very active like playing basketball or even just walking, they will only maintain a pose for a fraction of a second.

Gesture allows you to quickly convey what your subject is doing. It gives a solid foundation so that when the drawing is further developed the figure maintains a fluid, orchestrated rhythm. If this foundation is weak, the final drawing will be, too. I cannot overemphasize the importance of this stage of the drawing.

Mastering this stage will develop your drawing skill more than any other chapter in this book. If you establish a clear gesture, your overall drawing will begin to take on a dynamic fluidity that is as individual as your handwriting.

The observational skills you developed in the last chapter will come in handy when you see an action you want to capture. Watch your subject so you can capture his or her pose.

USE GESTURE DRAWINGS TO CAPTURE THE ACTION
These gestures capture poses with as few lines as possible. The lines don't copy actual contours of the figure but simple rhythms and placement of the limbs and torso. At this stage, you should be more concerned with capturing the action as quickly as possible than drawing a figure.

"The essence of drawing is the line exploring space."
—Andy Goldsworthy

STEPS TO GESTURE DRAWING

Developing a consistent step-by-step approach will help
you avoid any hesitation when beginning a drawing.
Once you have internalized this artistic process it will
free your mind to concentrate on what you're trying to
communicate rather than how to draw. That is not to say
you can't change the procedure to suit your needs, but
as a rule, you will be better off approaching each draw-
ing with a process you are comfortable with.

1| Begin With an Oval for the Head
*Keep in mind how the head tilts in space. The head is a good
place to start because it establishes a rough proportion for
the figure.*

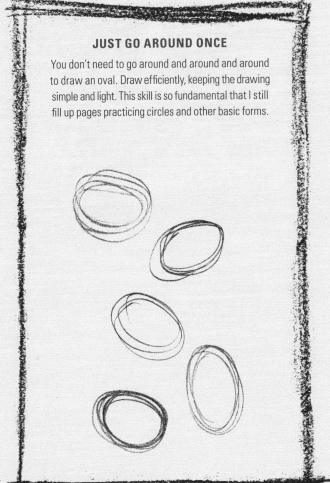

JUST GO AROUND ONCE

You don't need to go around and around and around
to draw an oval. Draw efficiently, keeping the drawing
simple and light. This skill is so fundamental that I still
fill up pages practicing circles and other basic forms.

2| Draw the Neck as It Pulls From the Head
*This line will roughly follow the movement of the spine. You
won't necessarily draw the anatomical position of the spine,
just its movement in relation to the head.*

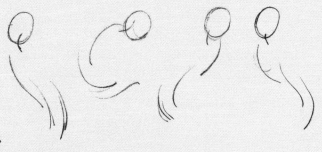

3| Continue Down the Body
*Capture the fluid movement of the torso. Notice that the
lines are basically single strokes. They're not "hairy" lines;
they are short little hatch marks.*

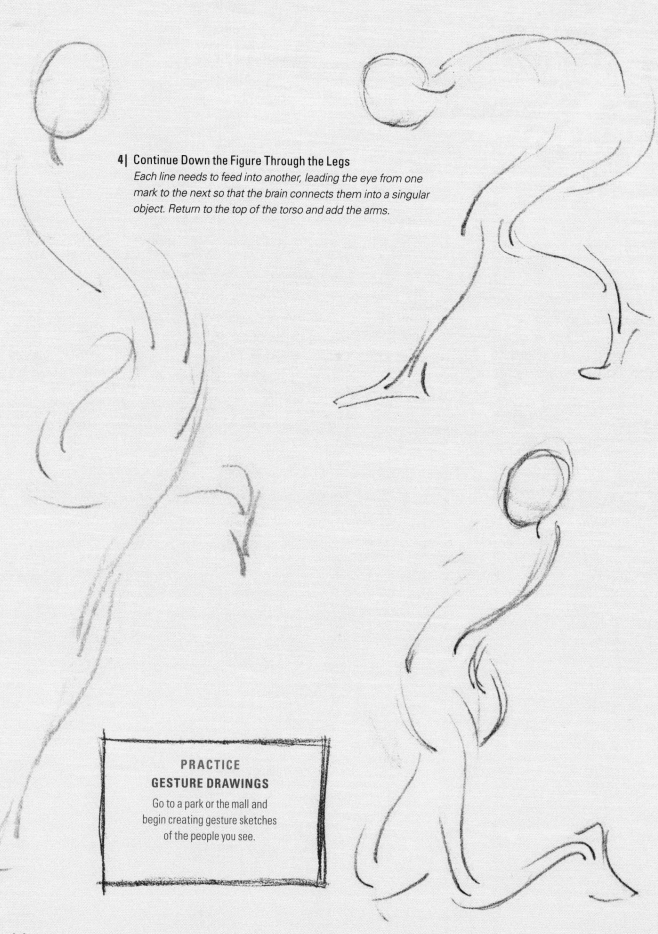

4| Continue Down the Figure Through the Legs

Each line needs to feed into another, leading the eye from one mark to the next so that the brain connects them into a singular object. Return to the top of the torso and add the arms.

**PRACTICE
GESTURE DRAWINGS**

Go to a park or the mall and begin creating gesture sketches of the people you see.

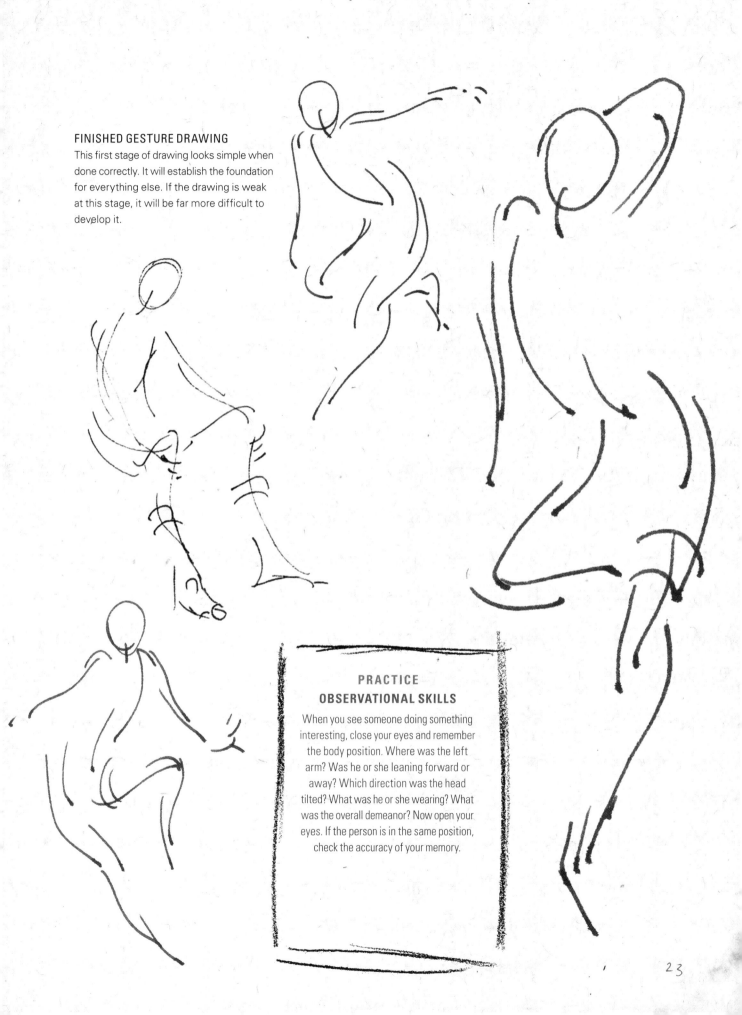

FINISHED GESTURE DRAWING

This first stage of drawing looks simple when done correctly. It will establish the foundation for everything else. If the drawing is weak at this stage, it will be far more difficult to develop it.

PRACTICE
OBSERVATIONAL SKILLS

When you see someone doing something interesting, close your eyes and remember the body position. Where was the left arm? Was he or she leaning forward or away? Which direction was the head tilted? What was he or she wearing? What was the overall demeanor? Now open your eyes. If the person is in the same position, check the accuracy of your memory.

DRAWING SPEED

Even though you are capturing something in motion, you don't have to rush. Be bold and lay down lines with confidence, but don't hurry. If your subject moves before you finish the gesture, you can rely on your memory, invent the rest of the pose or wait (people tend to fall back into the same position over time either because of a repeated action or an ingrained mannerism).

Keep in mind that although gesture drawings can be an end unto themselves, their purpose is to provide a framework to build on—so draw lightly. If you draw too heavily, you won't be able to correct proportion or positional problems as the drawing develops. As you continue to develop the drawing, after you have captured the gesture, these early light lines will fade into the background, but their influence will be seen in the final result.

GESTURE OF COMPOSITION

Gesture is always important. Just as a figure has a gesture that leads the eye from one body part to the next, a composition has a gesture that connects each element of the picture. This allows the artist to control how the viewer experiences the image. By linking separate parts through the larger gesture lines, the viewer can see the connections between separate parts of the image. This principle can clearly be seen when analyzing masterworks.

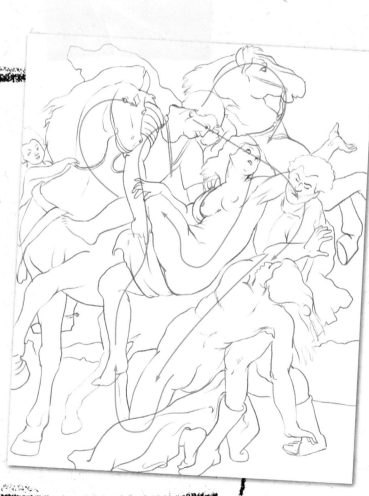

In *Rape of the Daughters of Leucippus* (1618), Peter Paul Rubens is interpreting a story by Theocritus and Ovid of the abduction of the daughters of King Leucippus by twin brothers Castor and Pollux. The composition's gesture shows how intertwined the characters are, literally and figuratively.

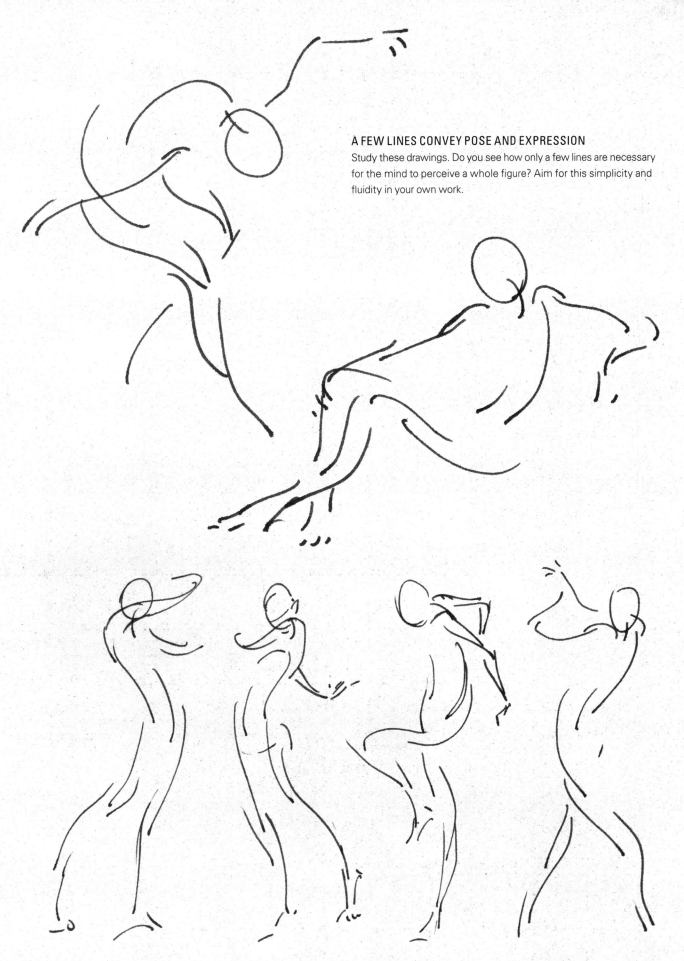

A FEW LINES CONVEY POSE AND EXPRESSION

Study these drawings. Do you see how only a few lines are necessary for the mind to perceive a whole figure? Aim for this simplicity and fluidity in your own work.

BASIC FORMS

Once you have established a gesture, you will want to begin to define it dimensionally. By going through the drawing a second time, you can use spheres, boxes and cylinders to establish how the figure is positioned spatially. While a gesture gives you a feeling for a pose, it's the basic forms that begin to make the figure seem like it has mass.

Though the body isn't made up of spheres or boxes or cylinders, these will later help you to sculpt out muscles, bone and flesh from the flat page. They also serve as a surface on which to hang details such as the nipples, the bellybutton, scars or tattoos. Ultimately, you need to develop a model of a figure in your mind that you can draw from any angle, in any pose and to any level of detail without having an actual person in front of you. Once you achieve this, drawing is just a matter of altering shapes to conform to your specific subject.

When you are drawing from life, your drawing must ultimately emulate what you observe. But conceptual drawing is necessary to re-create on a flat page what you see in reality. You are melding the two techniques of drawing—drawing what you see and drawing what you know—and one is not more important than the other.

Being able to construct a figure from imagination gives you the control to alter what you see and the freedom to invent figures and environments. You aren't limited by what's in front of you; you can draw whatever you imagine. But using your observations gives you new inputs so you aren't repeating the same drawings over and over again.

The techniques in this chapter will help you to better translate what you see into a drawing that appears to have actual volume and dimension.

BASIC FORMS CREATE A SENSE OF VOLUME
This figure was created by building basic forms on top of a gesture. For example, the square knees, the round breasts and the cylindrical limbs all have the basic forms as their foundation.

"Art does not reproduce the visible; rather, it makes visible."
—Paul Klee

SPHERICAL FORMS

The sphere is more than a circle; it takes up three-dimensional space. This is somewhat an intellectual understanding because a circle and sphere look the same on a flat page, but it affects the way you develop details on top of it.

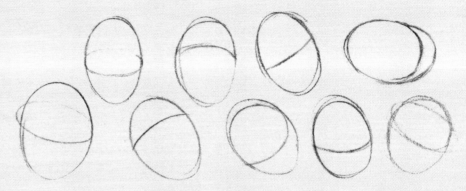

CROSS-CONTOUR LINES
On a gesture drawing, the head may be depicted by just a circle. When you go back through the drawing a second time, add a cross-contour line to establish how the head is oriented in space. A line drawn around the sphere will help you define whether the head is tipping forward or back.

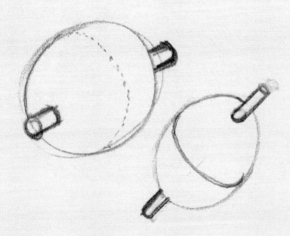

ADDING THE EQUATORIAL LINE
When a sphere is elongated into an ellipsoid, as we are using for the head, it takes on a certain orientation along its long diameter. The equatorial line must be placed at a ninety-degree angle from the long diameter. This line represents where the eyes are on a head.

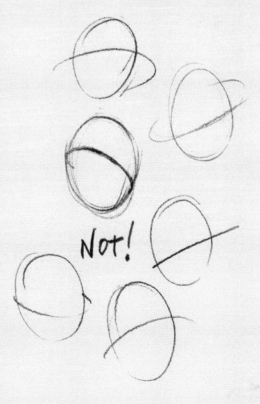

PLACE THE LINE CAREFULLY
If the equatorial line is just placed haphazardly, as shown here, the illusion of dimension is lost.

SQUASHED, STRETCHED & TWISTED SPHERES

The next step is gaining the skill to mold a sphere into any shape. Practice drawing the spherical form as if it were twisted, stretched or bent over. Also try merging two separate spherical forms together to come up with an endless number of variations. These forms can even become simple characters that take on personalities if you allow them. If you have trouble visualizing the twists and bends, play around with a little bit of clay and study how twisting, stretching and bending it affects the shapes and contours.

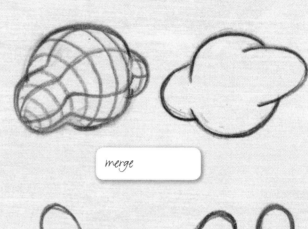

merge

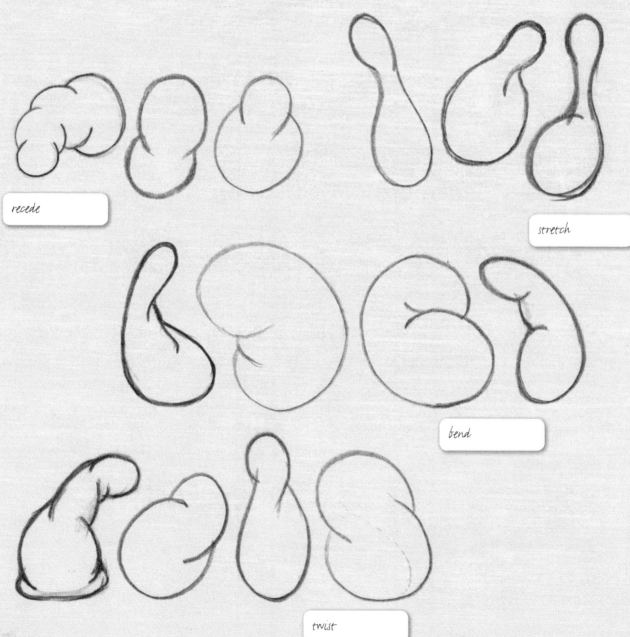

recede

stretch

bend

twist

28

SPHERICAL FIGURES

Once you understand how to mold spheres into more complex shapes, it is not a difficult jump to using spheres to create simple anatomical forms. The figure on this page was created using only modeled and interconnected spheres. The figure appears to have real mass because it takes advantage of the sphere's simple, volumetric form.

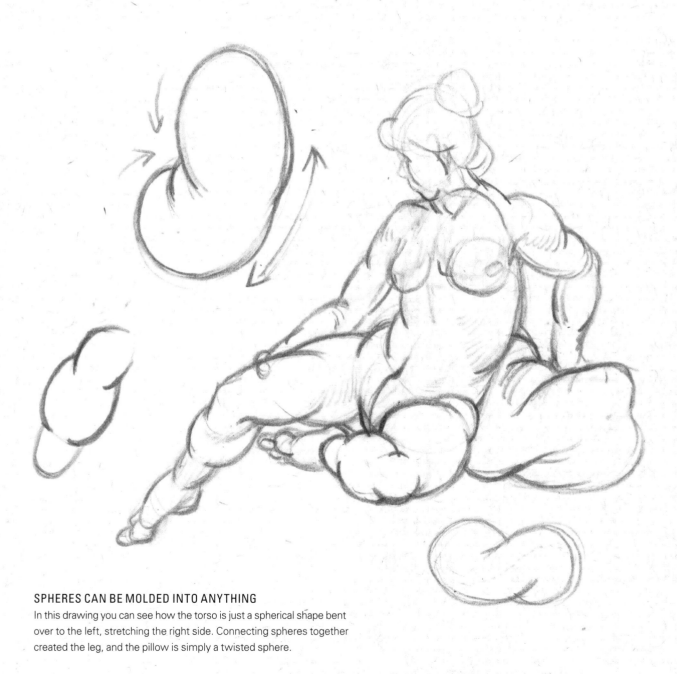

SPHERES CAN BE MOLDED INTO ANYTHING
In this drawing you can see how the torso is just a spherical shape bent over to the left, stretching the right side. Connecting spheres together created the leg, and the pillow is simply a twisted sphere.

PRACTICE: SPHERICAL FIGURES

Analyze how spheres were used to create these figures.
Get tracing paper and draw the spheres themselves along
with cross-contour lines that you wrap around each form.

FIGURES BUILT FROM SPHERES

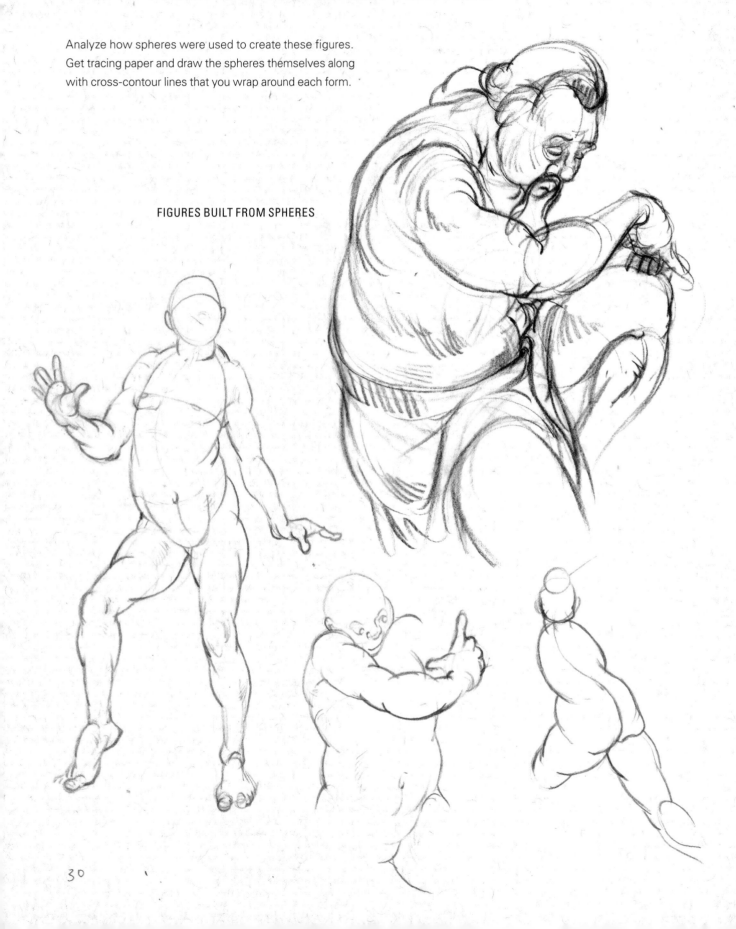

CUBIC FORMS

The cube is the most dimensionally defined of the three basic forms. Its obvious corners and edges clearly show the changes of plane. A cube has an unmistakable orientation. It is obviously above or below or rotated in space.

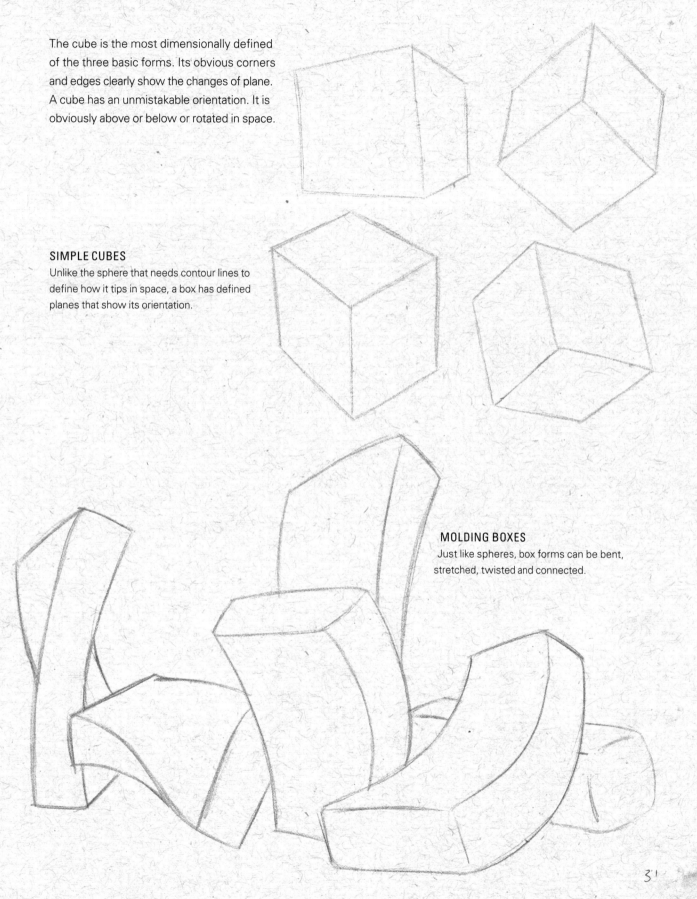

SIMPLE CUBES
Unlike the sphere that needs contour lines to define how it tips in space, a box has defined planes that show its orientation.

MOLDING BOXES
Just like spheres, box forms can be bent, stretched, twisted and connected.

BUILDING CUBIC FIGURES

Just as when you built the figure from spheres, you build the figure using box forms. Boxes are an easy tool to use to quickly define a figure in three-dimensions, as they clearly separate the front, side and back planes. Using boxes is neither better nor worse than using spheres, it is simply a different technique to use to create volume.

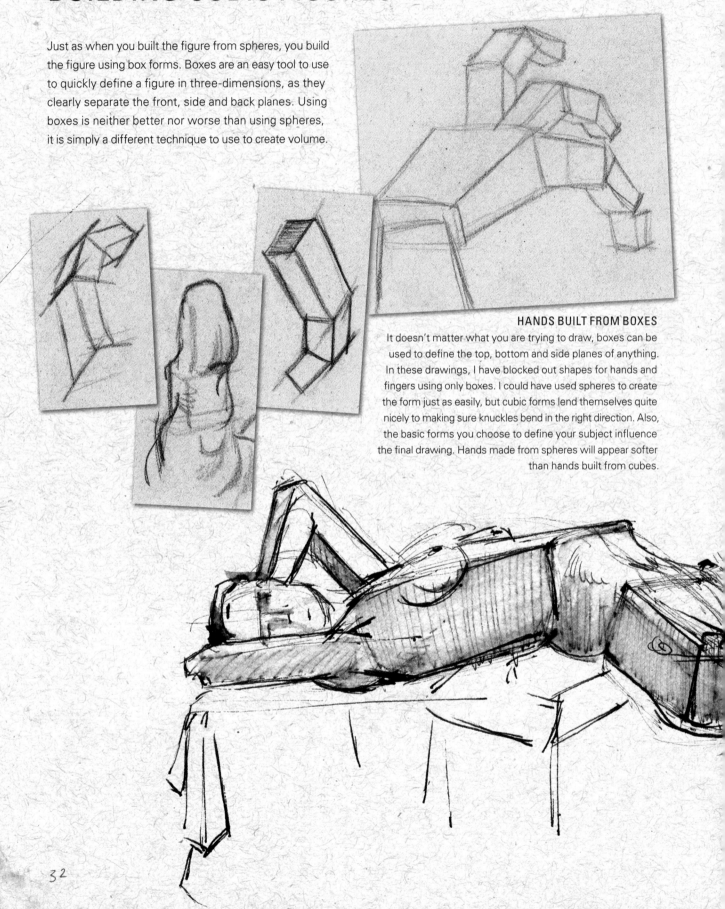

HANDS BUILT FROM BOXES

It doesn't matter what you are trying to draw, boxes can be used to define the top, bottom and side planes of anything. In these drawings, I have blocked out shapes for hands and fingers using only boxes. I could have used spheres to create the form just as easily, but cubic forms lend themselves quite nicely to making sure knuckles bend in the right direction. Also, the basic forms you choose to define your subject influence the final drawing. Hands made from spheres will appear softer than hands built from cubes.

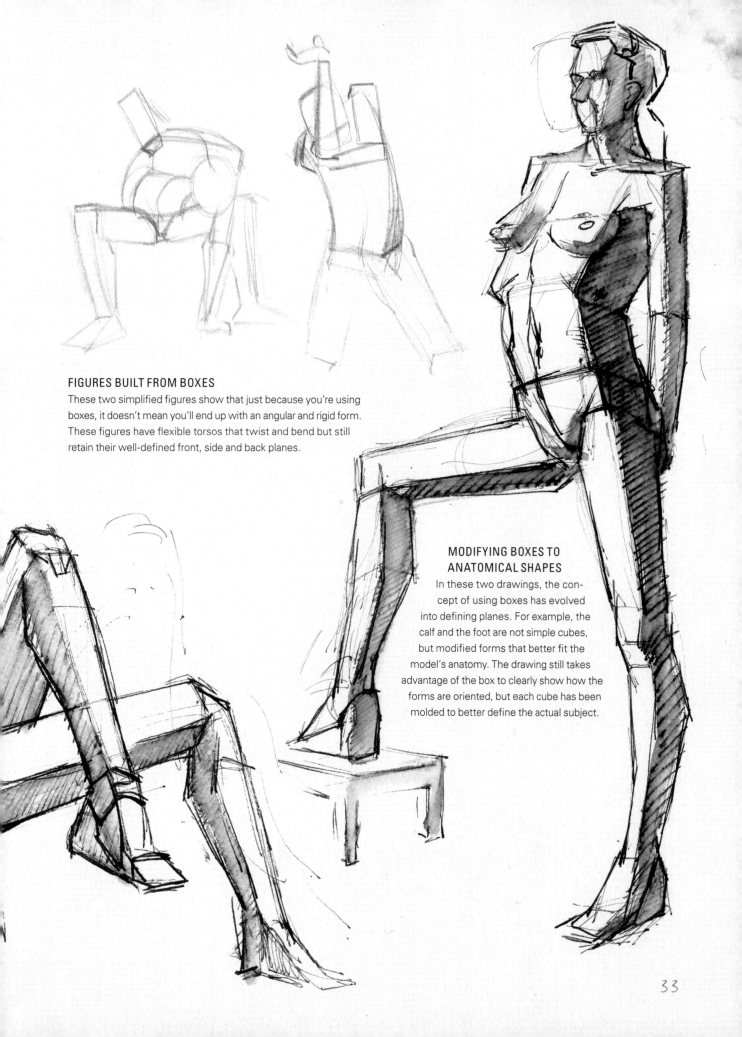

FIGURES BUILT FROM BOXES

These two simplified figures show that just because you're using boxes, it doesn't mean you'll end up with an angular and rigid form. These figures have flexible torsos that twist and bend but still retain their well-defined front, side and back planes.

MODIFYING BOXES TO ANATOMICAL SHAPES

In these two drawings, the concept of using boxes has evolved into defining planes. For example, the calf and the foot are not simple cubes, but modified forms that better fit the model's anatomy. The drawing still takes advantage of the box to clearly show how the forms are oriented, but each cube has been molded to better define the actual subject.

CYLINDRICAL FORMS

The cylinder shares qualities with the sphere and the cube.
It is an extruded round form but, like the box, has well-defined
edges and clear dimension. The cylinder is an excellent
shape to define the arms, legs, fingers and neck,
to name just a few examples.

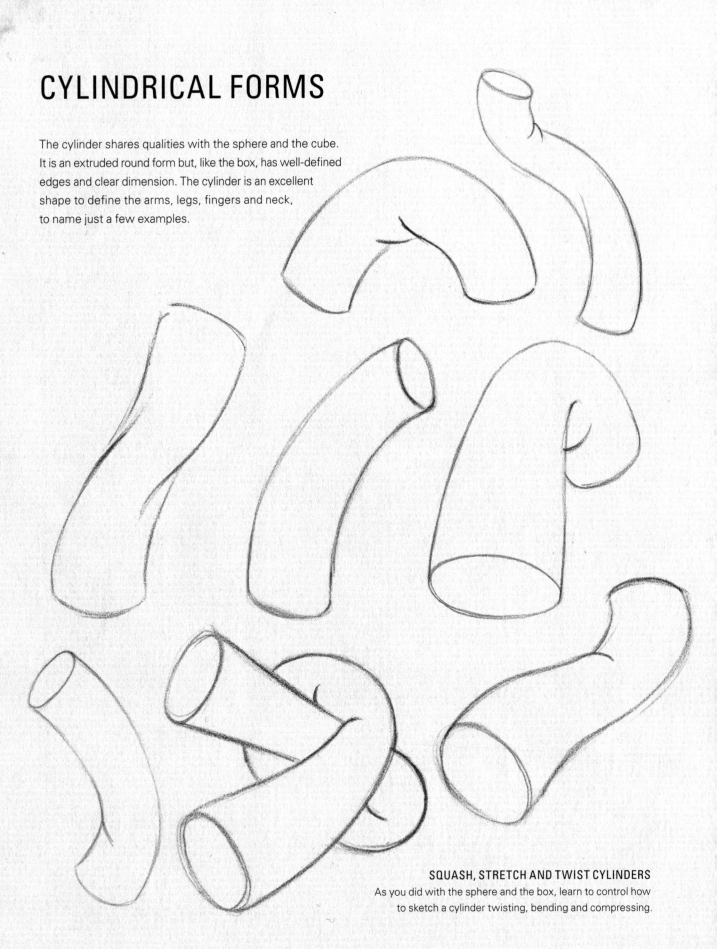

SQUASH, STRETCH AND TWIST CYLINDERS
As you did with the sphere and the box, learn to control how
to sketch a cylinder twisting, bending and compressing.

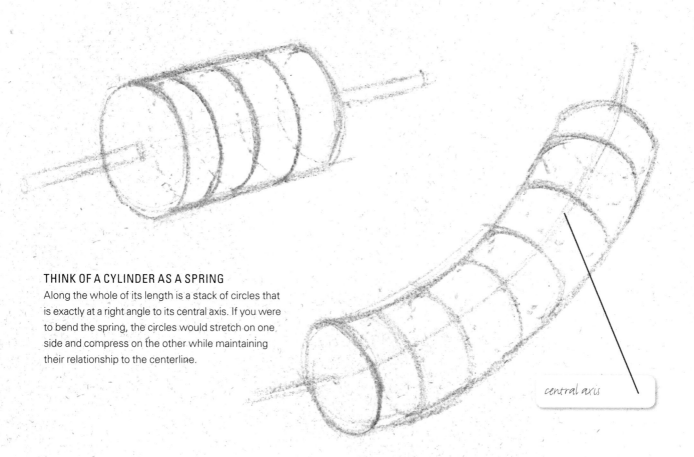

THINK OF A CYLINDER AS A SPRING

Along the whole of its length is a stack of circles that is exactly at a right angle to its central axis. If you were to bend the spring, the circles would stretch on one side and compress on the other while maintaining their relationship to the centerline.

central axis

CROSS-SECTIONAL CIRCLES ARE KEY

Learning to draw over the surface of the cylinder will help you develop forms that have real substance and weight. The ability to accurately draw the cross-sectional circles on the surface of the cylinder is what allows you to place details and texture on a form and maintain the illusion of three-dimensionality.

FOR PRACTICE

Stretch and bend a Slinky on a table and draw how the ellipses change as the coils curve in different directions.

COMBINING FORMS

When constructing a drawing, you don't have to settle on just spheres or boxes or cylinders; you use all of them in tandem as appropriate for the subject.

If you are drawing a tall, thin woman, it would be suitable to use cylinders for the arms and legs. If you are drawing a fat man, spheres would be better. However, even on the tall, thin figure, you will find areas where spheres and boxes best define that part of the form. You have to analyze the subject and decide how to best describe it.

PRACTICE USING TRACING PAPER

Use tracing paper to define basic forms over photos or draw on the images in a magazine or newspaper.

BASIC FORMS
This figure is broken down into various basic forms: a spherical form for the upper torso, a box form for the hips and cylinders for the arms and legs.

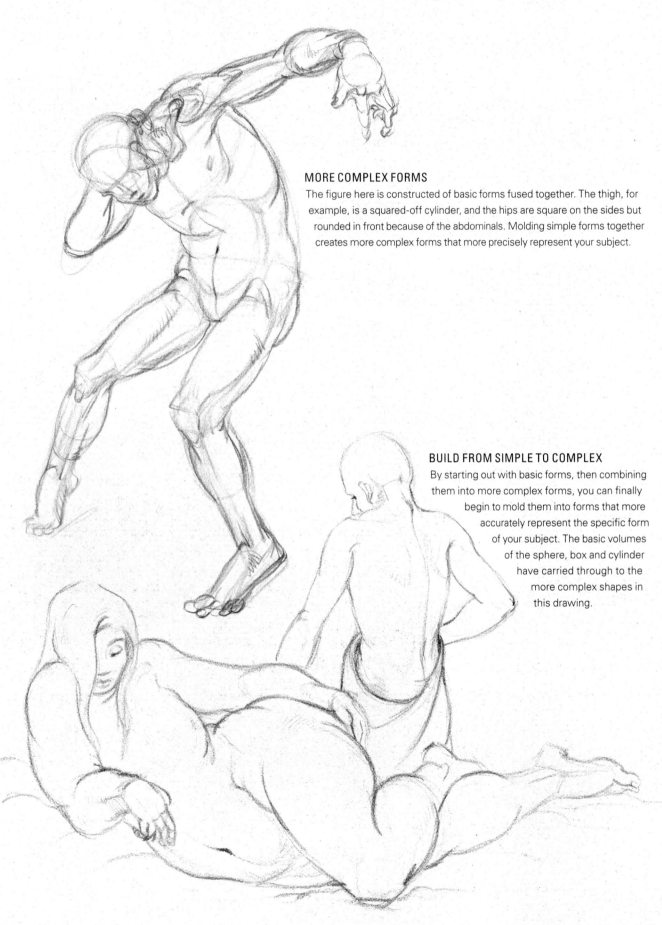

MORE COMPLEX FORMS

The figure here is constructed of basic forms fused together. The thigh, for example, is a squared-off cylinder, and the hips are square on the sides but rounded in front because of the abdominals. Molding simple forms together creates more complex forms that more precisely represent your subject.

BUILD FROM SIMPLE TO COMPLEX

By starting out with basic forms, then combining them into more complex forms, you can finally begin to mold them into forms that more accurately represent the specific form of your subject. The basic volumes of the sphere, box and cylinder have carried through to the more complex shapes in this drawing.

37

ANATOMICAL FORMS

As mentioned in chapter one, learning to draw anatomy is more than just knowing the muscles; you have to understand their form. You have to know what they look like three-dimensionally so you can draw them from any angle. By simplifying the muscles into the basic shapes and then molding them into more accurate forms, you will easily be able to construct a figure from imagination.

SIMPLE STRUCTURES
This arm is broken down into box shapes. You can clearly see how the parts relate and inter-connect. The clear structure makes developing the more anatomically correct drawing easier.

BASIC MUSCLE FORMS
Each muscle can be broken down into a basic form using a combination of spheres, boxes and cylinders. In this drawing, the triceps muscle is simplified into a modified wedge shape. The actual anatomical form (the middle sketch) is developed from spherical forms in the middle, then stretched out into cylinders where the muscle connects to the bone. In the third sketch, skin and shading are added, but you can clearly make out the underlying form.

PRACTICE BASIC FORMS

Practice drawing the basic forms like a musician practices scales and arpeggios.
The sphere, box and cylinder are the fundamental building blocks of art.

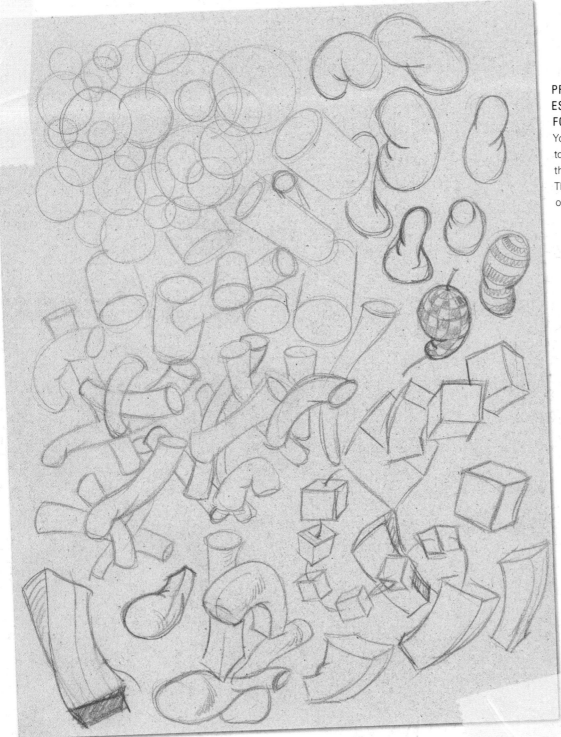

PRACTICE THESE ESSENTIAL FORMS OFTEN
You can never get too good at drawing the basic forms. They are at the core of artistic skill.

BUILDING FORM FROM GESTURE

Here's a summary of how you can create sketches from gesture drawings.

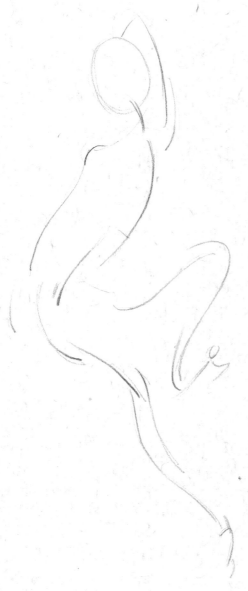

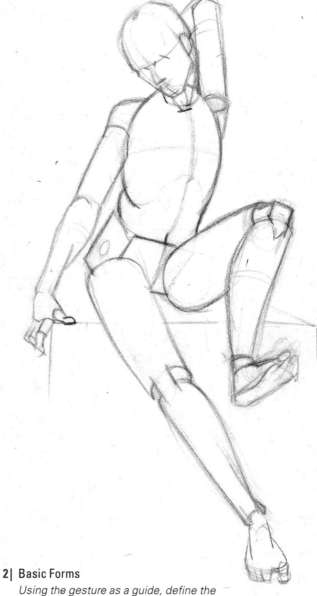

1| Gesture Foundation

A simple gesture drawing captures the action of your subject. This step should be done in a short amount of time, but it shouldn't be rushed.

2| Basic Forms

Using the gesture as a guide, define the figure's three-dimensional volumes using the simple forms of the sphere, box and cylinder.

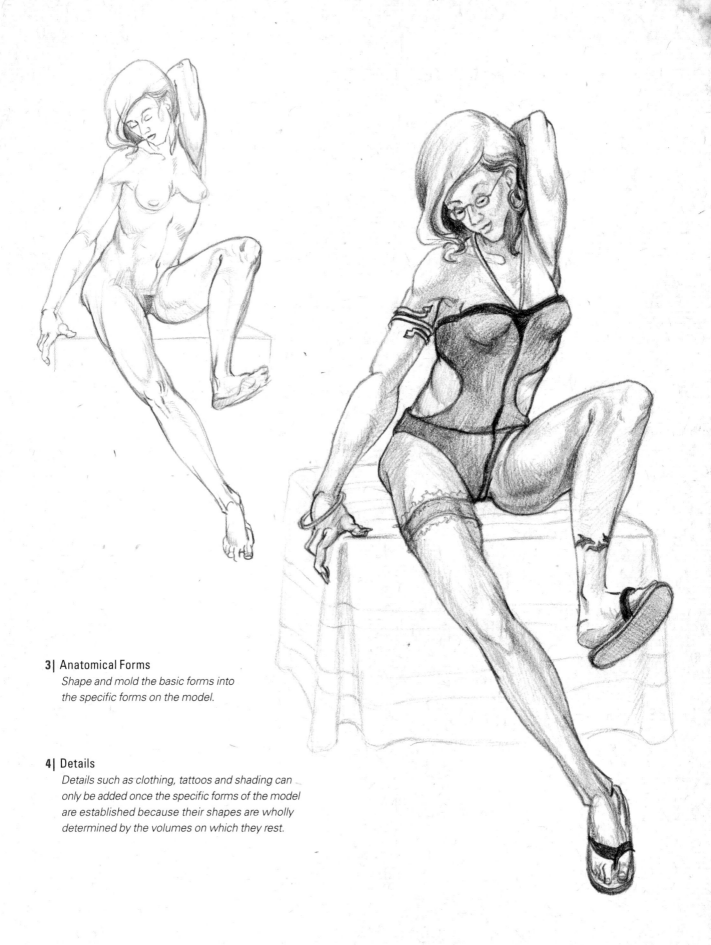

3| Anatomical Forms

Shape and mold the basic forms into the specific forms on the model.

4| Details

Details such as clothing, tattoos and shading can only be added once the specific forms of the model are established because their shapes are wholly determined by the volumes on which they rest.

FORMS & GESTALT

Gestalt is a psychological term that basically means that the mind will make a connection between separate parts and formulate a unified idea out of them because they seem to go together. In art, the gestalt principle means that a viewer sees a drawing as an object, even though not every line is present. This means that when you draw, you don't have to delineate the whole form; just by drawing part of it, the viewer sees the whole thing.

GESTALT ILLUSION
Even though no lines are touching and the outside contour lines aren't there, the mind completes the image of the zebra. The drawing becomes more than just the sum of its parts. Notice how much you can leave out of a drawing and still have it recognizable.

GAPS IN THE FORM
On a more basic level, you can see the spheres even though the lines don't fully encapsulate the whole form. We still perceive all of them as round objects. But by not completing the whole form, the eye is guided through the space and on to a connected shape.

GESTALT AND BASIC FORMS
In this example, you can see how the box form passes through the sphere. Neither the box nor the sphere is drawn in total, but we can still clearly see the two forms. The arm is based on the box and sphere shapes, but we don't notice them because of the gestalt principle.

ALIGNMENT

In order for the gestalt principle to work, you have to make sure the parts of the form you draw properly connect. In the first drawing you can see how the two sides of the cylinder line up, and we perceive it as one form blocked by a cone. In the second drawing the two sides don't line up, and we see them as two separate cylinders. This is especially important when you are drawing, for example, someone with one leg crossing behind another. If you try to draw one side then later come back and draw the other side, chances are you will have alignment problems. It's better to draw the whole leg at the same time, leaving out the area where it is blocked.

GESTALT AND GESTURE

The gestalt principle can also be applied to the gesture to quickly indicate its three-dimensional qualities without having to carefully render every sphere, box and cylinder. By just indicating parts of the forms, the mind perceives the volume. The cross-contour lines over the gesture are all the mind needs to see the form.

SKETCHING WITH VOLUMES

Once you have a feel for gesture drawing, it is not always necessary to actually draw the gesture lines before you begin establishing the volumes. If your subject is relatively stationary, you can quickly establish the basic volumes of the form, sketching with the actual three-dimensional shapes. The gesture is still just as important, even though you aren't putting it down on paper. Keep in mind that even if you don't draw the gesture, your goal should be the same: to quickly establish a total figure. The sketch needs to be more than just a collection of parts; it should be a fluid whole that provides a foundation to build on top of.

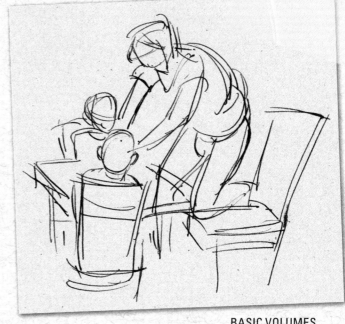

BASIC VOLUMES

This quick sketch establishes the basic volumes of the scene. The simple spheres of the woman's torso, the cylinders of the legs, and the boxes in the chair were done without first putting down a gesture. While it takes a little bit longer to draw a figure using shapes rather than gesture lines, the three-dimensional elements are developed earlier.

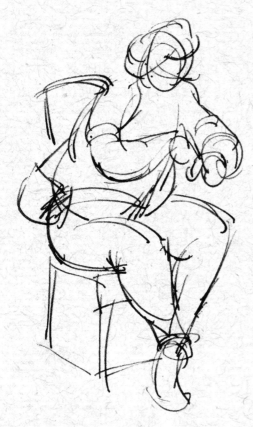

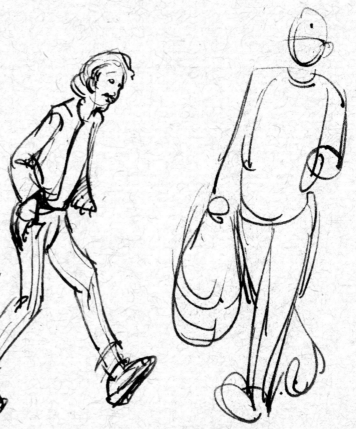

CAPTURING THE ACTION

All gesture drawing is about capturing the pose as quickly as possible. In these three drawings, the basic shapes are used to capture the action. The volumes are loose but establish just enough to convey both the pose and the spatial properties of the figures.

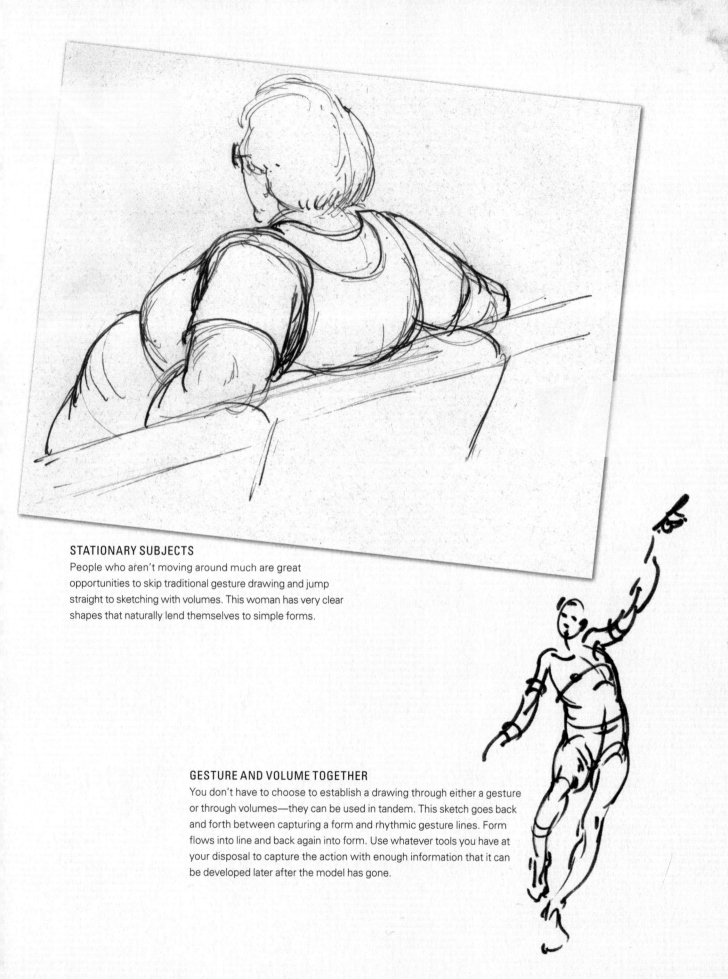

STATIONARY SUBJECTS

People who aren't moving around much are great opportunities to skip traditional gesture drawing and jump straight to sketching with volumes. This woman has very clear shapes that naturally lend themselves to simple forms.

GESTURE AND VOLUME TOGETHER

You don't have to choose to establish a drawing through either a gesture or through volumes—they can be used in tandem. This sketch goes back and forth between capturing a form and rhythmic gesture lines. Form flows into line and back again into form. Use whatever tools you have at your disposal to capture the action with enough information that it can be developed later after the model has gone.

Chapter Four
DRAPERY

"So whether it's the look of the person... the clothes they wear, the mannerisms they have... those are externals but... it helps give you a clue as to maybe what's going on beyond that."
—Joe Mantegna

Although clothing tends to cover up the forms we discussed in the last chapter, those underlying forms are what dictate the patterns of folds as the cloth is supported and suspended over the figure.

Regardless of the sheerness or heaviness of the cloth, garments follow the contours of the underlying form in areas where the clothes are clinging to the body, be it due to gravity or because the fabric is being pulled and stretched against the figure. Therefore, even when drawing a clothed figure, you must first work out the volumes of the body as if your subject were nude, then you will have a framework on which to convincingly hang the costume.

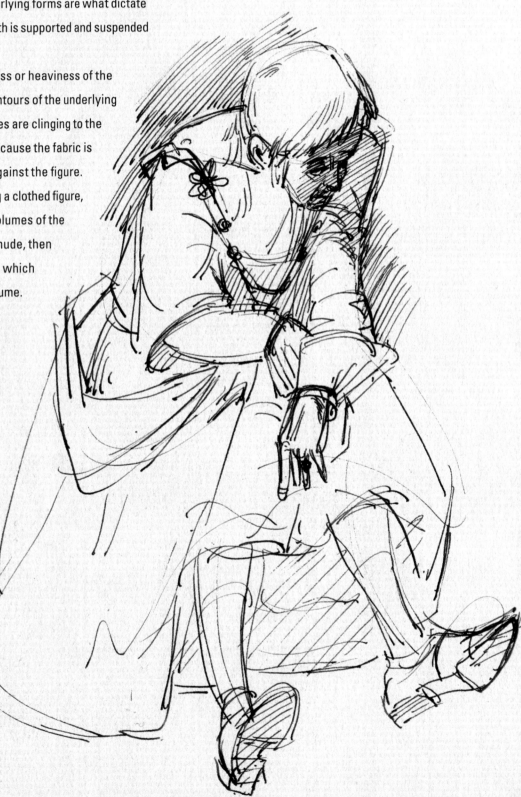

DRAPERY FOLLOWS FORM
Notice how in this sketch all the fabric and folds of this woman's dress wrap around her figure, giving the drawing a stronger sense of dimension.

TENSION & COMPRESSION

Folds are created when cloth is in either tension or compression. Hanging folds (pipe fold and swag fold) occur when fabric is in tension and being held up against the pull of gravity. Compression folds (interlocking fold and spiral fold) are created when fabric is pushed together and begins to bunch up on itself.

Tension and compression are often both present to create a fold. Hybrid folds (zigzag fold and billowing fold) are created when both tension and compression forces are acting on the cloth.

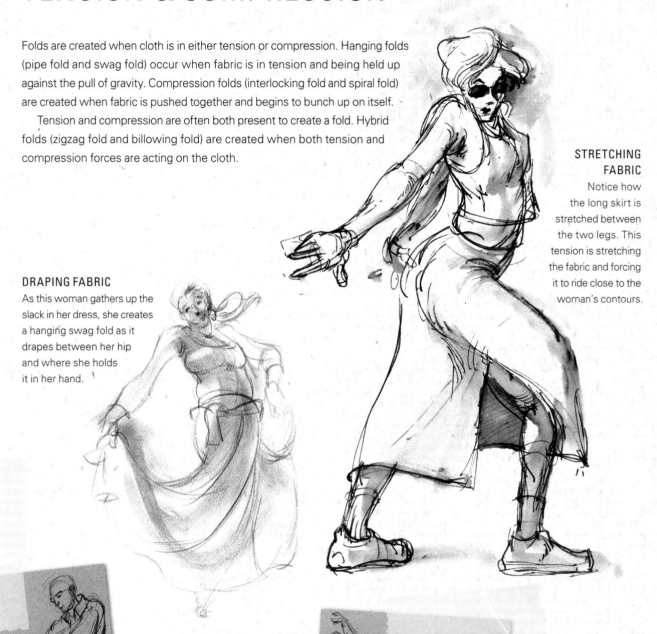

STRETCHING FABRIC
Notice how the long skirt is stretched between the two legs. This tension is stretching the fabric and forcing it to ride close to the woman's contours.

DRAPING FABRIC
As this woman gathers up the slack in her dress, she creates a hanging swag fold as it drapes between her hip and where she holds it in her hand.

COMPRESSING FABRIC
The fabric in the sleeves is largely under compression as gravity pulls it back down the outstretched arms. Spiral folds become more prominent as the fabric folds around itself at the shoulder.

HANGING FABRIC
This man has rotated his shoulders forward, causing his shirt to compress and gather across his front. At the same time, the fabric is pulled down by gravity and forms pipe folds as it drops down from his shoulders. Both lateral compression and vertical tension go into creating this fold pattern.

47

PIPE FOLD

The pipe fold is the simplest form of a hanging fold. It's created when cloth is suspended from a single point and gravity tugs downward on the rest of the fabric. As the material stretches from the suspension point, the undulating wave pattern of the pipe fold begins to form. Think of the pipe fold as a cone that points directly to the spot that holds the fabric up.

BASIC PIPE FOLD
First, locate the suspension point where the fabric is being held up against the pull of gravity. The thickness of the fabric will determine how wide the waves will be as they drop away from the suspension point.

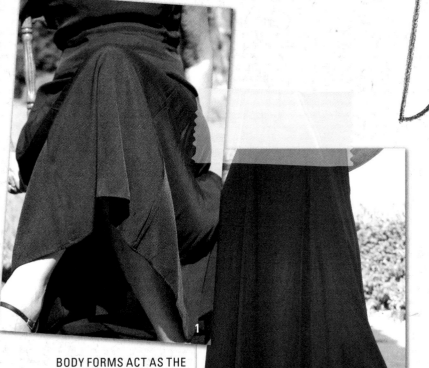

BODY FORMS ACT AS THE SINGLE SUSPENSION POINTS
Here, the pipe fold forms from the single suspension point of the knee (1). The waist is the point where the fabric gathers here (2), creating pipe folds throughout the skirt.

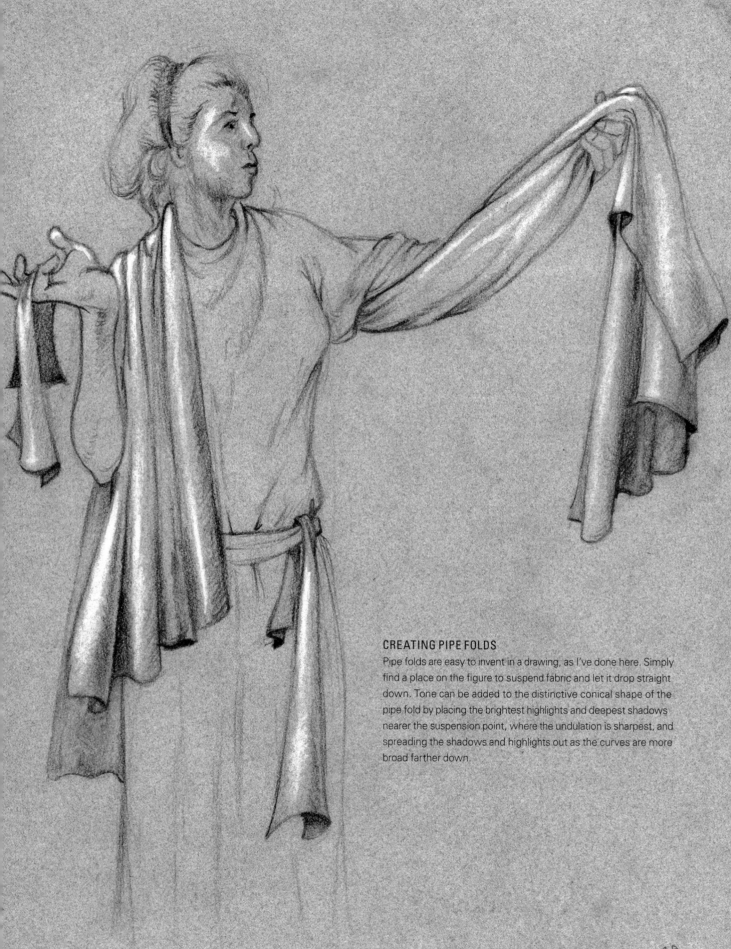

CREATING PIPE FOLDS

Pipe folds are easy to invent in a drawing, as I've done here. Simply find a place on the figure to suspend fabric and let it drop straight down. Tone can be added to the distinctive conical shape of the pipe fold by placing the brightest highlights and deepest shadows nearer the suspension point, where the undulation is sharpest, and spreading the shadows and highlights out as the curves are more broad farther down.

49

SWAG FOLD

The swag fold (also referred to as a *diaper fold*) is really a series of pipe folds that are suspended between two points and pulled downward by gravity in the middle, creating a downward arc pattern.

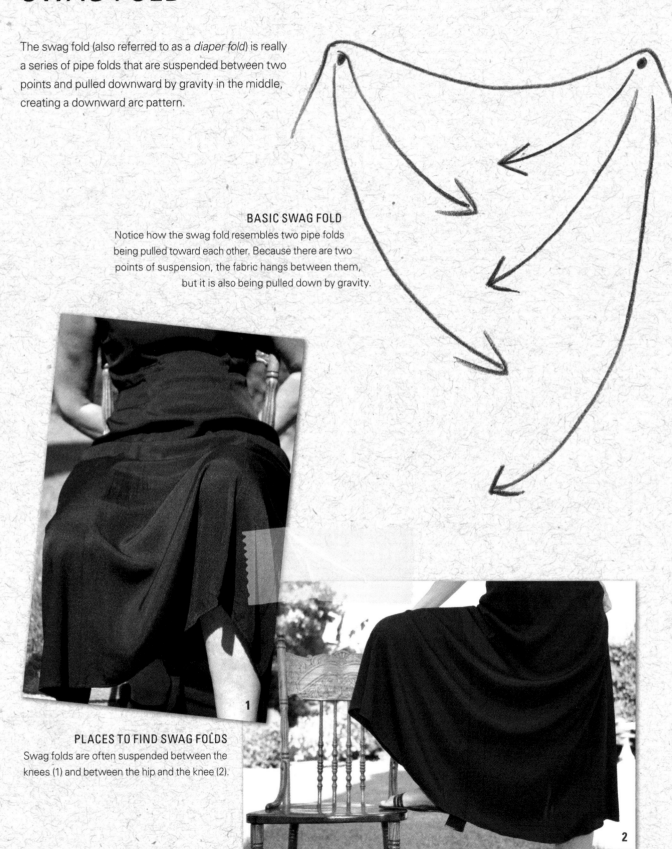

BASIC SWAG FOLD
Notice how the swag fold resembles two pipe folds being pulled toward each other. Because there are two points of suspension, the fabric hangs between them, but it is also being pulled down by gravity.

PLACES TO FIND SWAG FOLDS
Swag folds are often suspended between the knees (1) and between the hip and the knee (2).

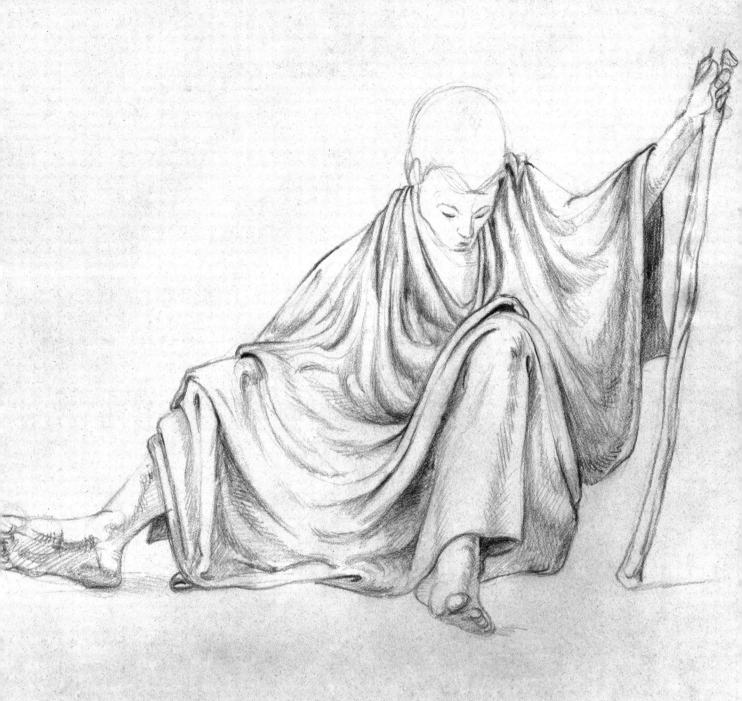

CREATING SWAG FOLDS

Find places on your subject where you can hang fabric between two points. I took advantage of several opportunities here to create swag folds: between the knees, between the shoulders, and between the shoulder and the outstretched arm.

INTERLOCKING FOLD

The interlocking fold materializes when fabric folds over on itself, creating a little pocket. This compression fold spreads out from an area where fabric is being shoved together, forcing it to bunch up.

BASIC INTERLOCKING FOLD
In this diagram, you can see how the vertical compression causes the fabric to fold over on itself, forming a small pocket.

PLACES THAT BEND
The interlocking fold often occurs at bent joints, such as the back of the knee and the front of the elbow.

CLOTHING HELPS TO CREATE CHARACTER

The clothes people put on tells us about them; it is part of their character. A construction worker has a certain wardrobe when working, as does a firefighter or police officer. Costumes need not be so distinct as a uniform; they can also be the fashionable attire of teenagers, the outdated clothes of your uncle, or the nondescript clothing of a shy person. Two people can be wearing the same clothing, but convey different messages (for example, if one's clothes were disheveled and the other's were neatly pressed). Also, a local language of clothes exists in every society. We all get an immediate impression of someone who dresses in the style of a particular group or subculture. These understandings are shortcuts to creating character and telling a story, but it's your job to create the individual depth.

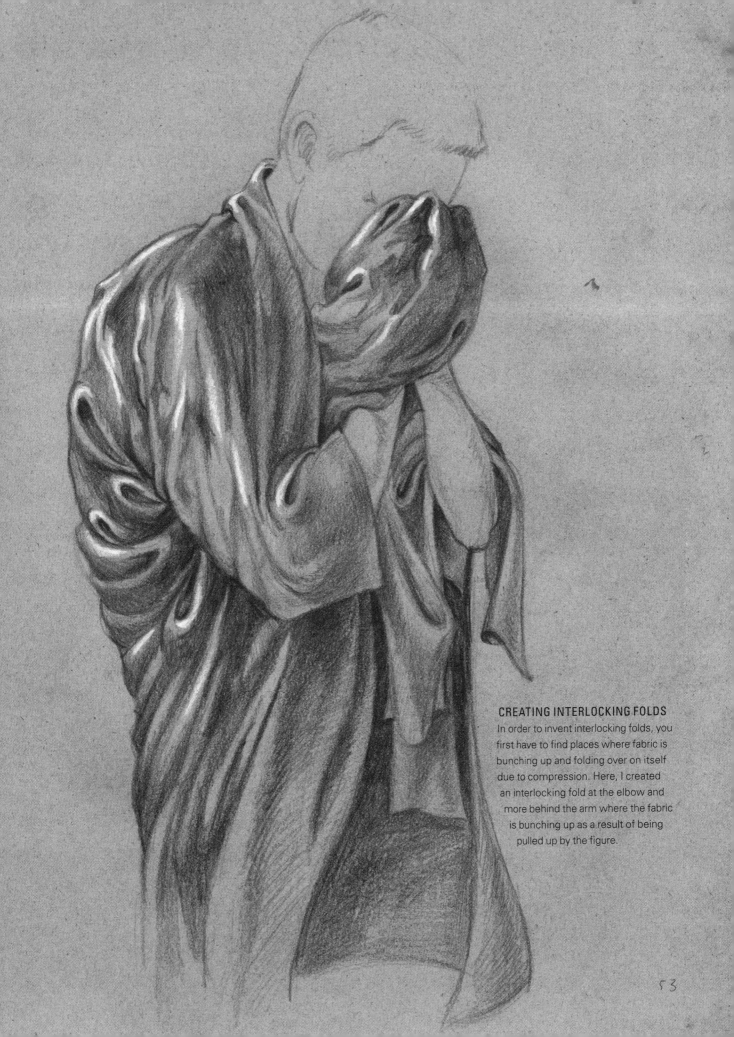

CREATING INTERLOCKING FOLDS
In order to invent interlocking folds, you first have to find places where fabric is bunching up and folding over on itself due to compression. Here, I created an interlocking fold at the elbow and more behind the arm where the fabric is bunching up as a result of being pulled up by the figure.

53

SPIRAL FOLD

The spiral fold is a series of folds that wind around the underlying form. The folds appear perpendicular to the direction of the compression. For example, if a shirtsleeve is pushed up the arm, the excess fabric will create folds that coil around the arm.

BASIC SPIRAL FOLD
This diagram shows how fabric might spiral around a cylindrical form such as an arm or leg.

FOLD THICKNESS
When drawing folds (above), be sure to show that the fabric has mass. Many artists make the mistake of depicting folds as lines rather than forms that wrap around the body.

LOOK FOR SPIRALS
Both the shirtsleeve (1) and the dress (2) spiral around the body where the fabric is compressed.

1

2

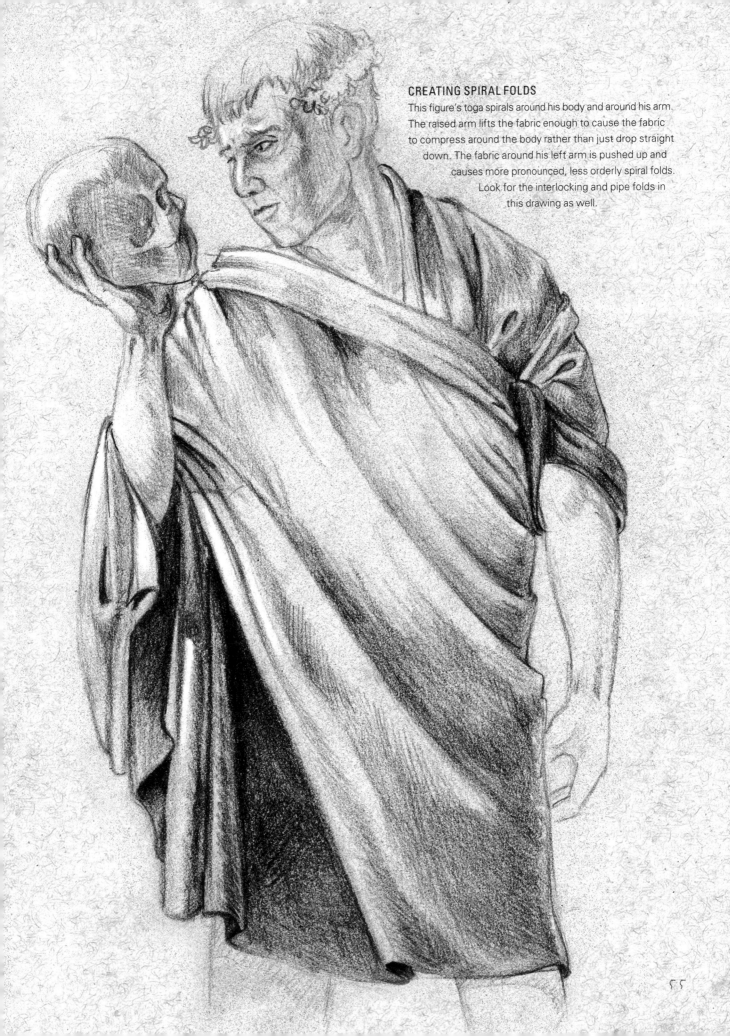

CREATING SPIRAL FOLDS

This figure's toga spirals around his body and around his arm. The raised arm lifts the fabric enough to cause the fabric to compress around the body rather than just drop straight down. The fabric around his left arm is pushed up and causes more pronounced, less orderly spiral folds. Look for the interlocking and pipe folds in this drawing as well.

ZIGZAG FOLD

The zigzag fold is a hybrid fold that has qualities of both tension and compression folds. When fabric drapes down like a pipe fold but is forced to bunch up on itself when it hits another surface, the fabric forms a zigzag pattern. The pipe fold never has a chance to develop, but the fabric never fully doubles over either, as in an interlocking fold.

BASIC ZIGZAG FOLD
The transition between the hanging fabric and that puddling on the floor forms the distinctive zigzag fold pattern.

FABRIC PUSHING UP
You can clearly see the zigzag shape forming along the front of the jacket as the material pushes up from the arm.

INTERRUPTED PIPE FOLDS
As these long pants begin to bunch up at the feet, zigzag folds begin to form along the ankles. Zigzag folds can be found anywhere fabric would naturally try to form a pipe fold but doesn't have enough room, causing the excess fabric to push up against the hanging fabric and forming the zigzag fold.

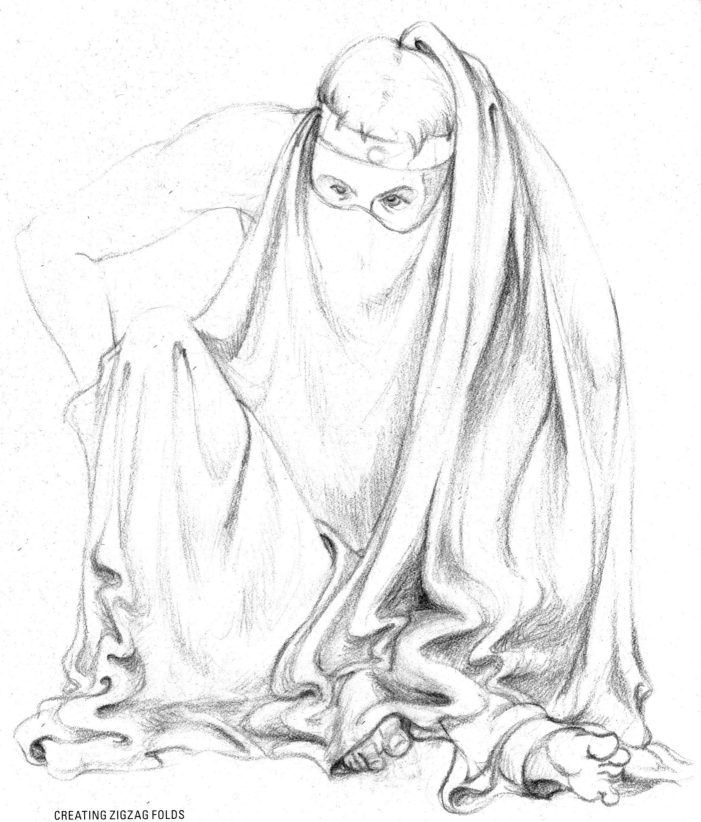

CREATING ZIGZAG FOLDS

Just above where the fabric meets the floor on this mysterious figure, zigzag folds have formed. If the cloth were free to hang it would form pipe folds, but since it begins to bunch up, zigzag folds are formed instead. The stiffness of the fabric plays a role in how high up the zigzag folds begin to form; the stiffer the fabric, the higher up the folds begin.

BILLOWING FOLD

The billowing fold (or *flying fold*) is created when wind is the dominant force acting on cloth, such as on a flag. Because the folds are dynamically swelling and gathering, the patterns are constantly changing, but the undulating surface forms large waves that travel across the length of the fabric. In addition, the cloth is usually anchored at various points that pull against the wind, where you can see loose pipe folds trying to form horizontally while interlocking folds may begin to form at the unsupported end.

BASIC BILLOWING FOLDS

Billowing folds are very dynamic; notice the overall undulating wave pattern consistent in the photos below. When analyzing a billowing fold, first look for the overall rising and falling of the cloth, then overlay any smaller folds that ride along the larger waves.

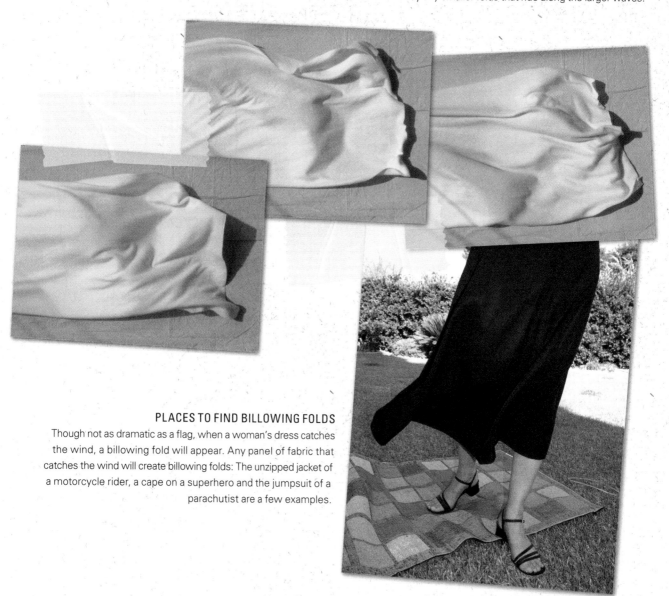

PLACES TO FIND BILLOWING FOLDS

Though not as dramatic as a flag, when a woman's dress catches the wind, a billowing fold will appear. Any panel of fabric that catches the wind will create billowing folds: The unzipped jacket of a motorcycle rider, a cape on a superhero and the jumpsuit of a parachutist are a few examples.

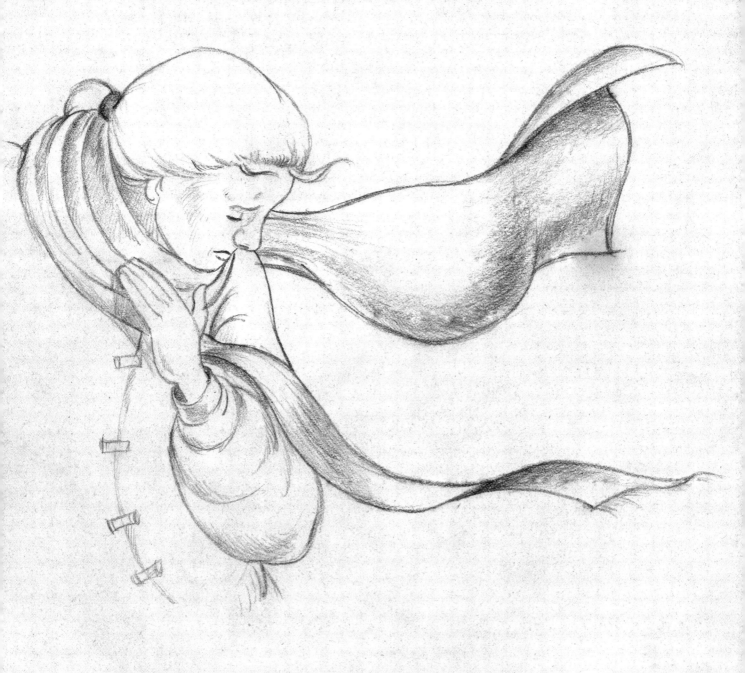

CREATING BILLOWING FOLDS

In this simple sketch, the woman's scarf has been caught by the wind. This is a basic billowing fold with clear hills and valleys. A more chaotic wind would create more complex billowing folds.

INERT FOLD

The inert fold is what happens to cloth that is piled on the floor. No forces are acting to pull it against gravity as in the pipe fold, nor are forces pushing it together as in the interlocking fold. The fabric sits lazily, undulating in and over, bunching here and stretching out there in no organized way. However, the overall appearance still needs to be designed so the drawing doesn't appear haphazard or messy.

BASIC INERT FOLDS

Inert folds may seem like a random mess, but their patterns still need to be designed by the artist. In this diagram you can see how there is a variety of forces that are moving in, out and around, but that they also seem organized.

PLACES TO FIND INERT FOLDS

As this dress puddles on the floor, inert folds are created. Inert folds are found anywhere cloth isn't being pulled or pushed by anything other than its own weight. A pile of clothes on the floor and a jacket sitting in someone's lap are a couple of other examples.

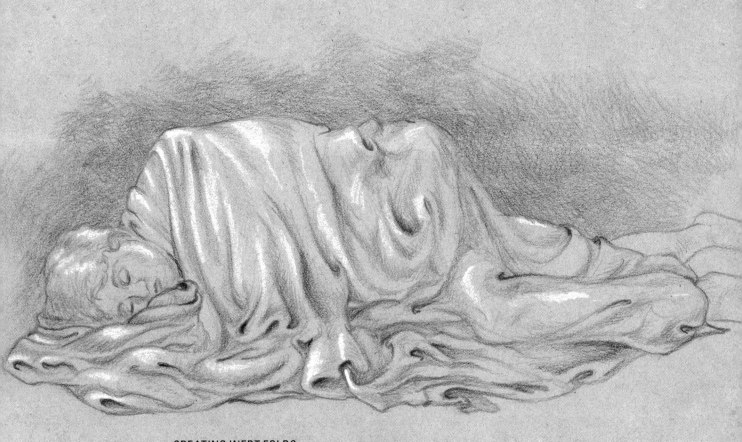

CREATING INERT FOLDS

While the blanket over this sleeping figure largely exhibits spiral folds, it rests on the floor in a pile of inert folds.

GESTURE OF CLOTH

Remember that everything you do in a drawing must reinforce the gesture and contribute to the illusion of three-dimensionality. The folds in clothing are a wonderful excuse to incorporate gesture lines into the final drawing, or they can show cross-contour lines that help define foreshortened volumes.

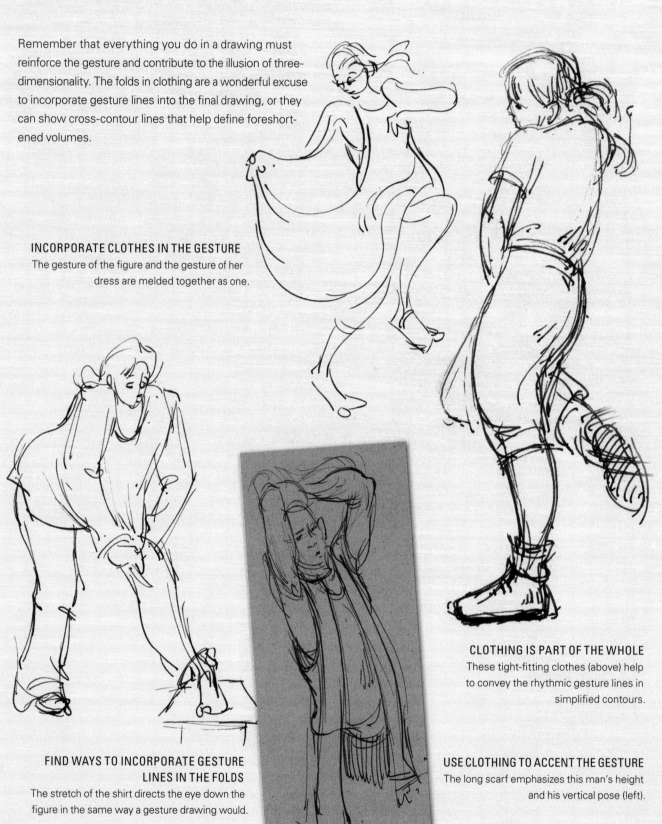

INCORPORATE CLOTHES IN THE GESTURE
The gesture of the figure and the gesture of her dress are melded together as one.

CLOTHING IS PART OF THE WHOLE
These tight-fitting clothes (above) help to convey the rhythmic gesture lines in simplified contours.

FIND WAYS TO INCORPORATE GESTURE LINES IN THE FOLDS
The stretch of the shirt directs the eye down the figure in the same way a gesture drawing would.

USE CLOTHING TO ACCENT THE GESTURE
The long scarf emphasizes this man's height and his vertical pose (left).

SIMPLIFYING

Though every wrinkle, fold and crease can be copied, the drawing won't really work unless you simplify and orchestrate the design into a harmonious whole. You can't simply draw a meaningless zigzag here and some random lines there; you have to define the underlying forms and reinforce the gesture.

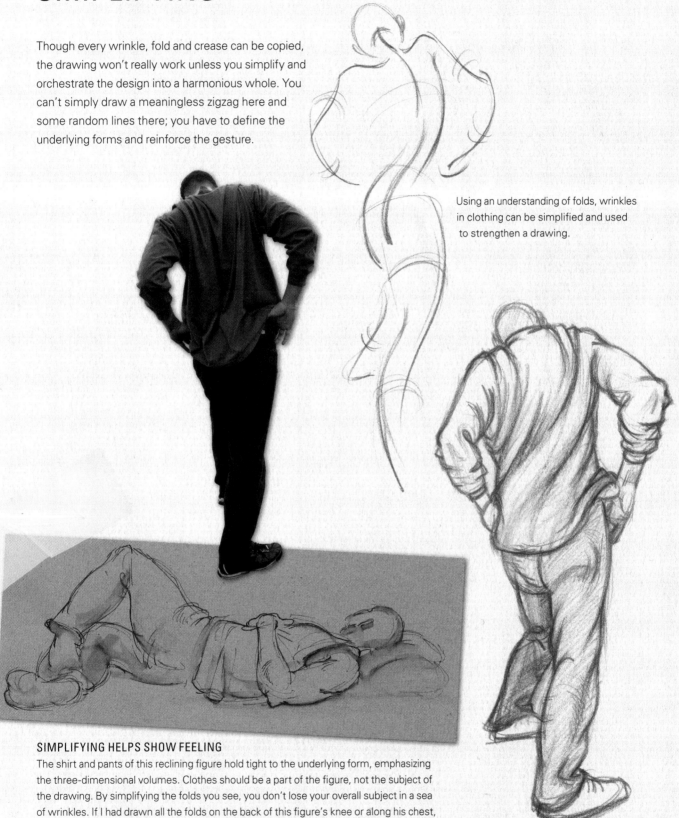

Using an understanding of folds, wrinkles in clothing can be simplified and used to strengthen a drawing.

SIMPLIFYING HELPS SHOW FEELING
The shirt and pants of this reclining figure hold tight to the underlying form, emphasizing the three-dimensional volumes. Clothes should be a part of the figure, not the subject of the drawing. By simplifying the folds you see, you don't lose your overall subject in a sea of wrinkles. If I had drawn all the folds on the back of this figure's knee or along his chest, I would have lost this overall form and the relaxed feeling I was trying to capture.

63

CREATING VOLUME WITH DRAPERY

As with everything else, in drawing, details come last. Clothing details, such as collars, pockets, hats, buttons and jewelry, need to reinforce the volume of the underlying form. Additionally, all details need to fit into the overall design of the drawing and should not call attention to themselves unless, of course, that adornment is the point of the drawing.

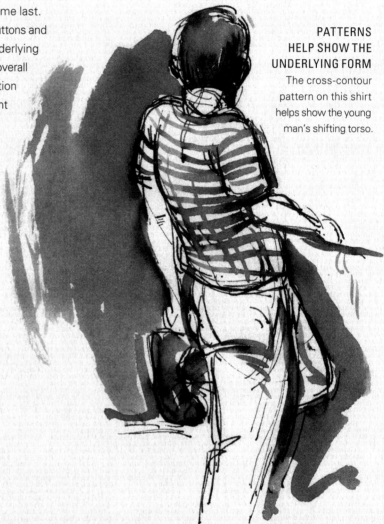

PATTERNS HELP SHOW THE UNDERLYING FORM
The cross-contour pattern on this shirt helps show the young man's shifting torso.

DETAILS HELP CREATE VOLUME
This man's jacket has several details that help create volume. The collar wraps around the neck, the belt wraps around the waist, the pocket helps show the curve at the hip, the seam and details along the back help define the centerline and the seam at the shoulder helps show the roundness of the arm.

BASIC FORMS CREATE VOLUME
This puffy jacket has seams that are simple spherical forms stacked on top of each other.

FROM GESTURE TO SKETCH

Just as the gesture provides a foundation for the form, the form is the foundation for the clothes. The gesture must always come first. Once the gesture is established, the volumes can be defined using simple shapes and anatomical forms. Then, clothes can be added on top of the form, keeping in mind the underlying volumes and the overall gesture.

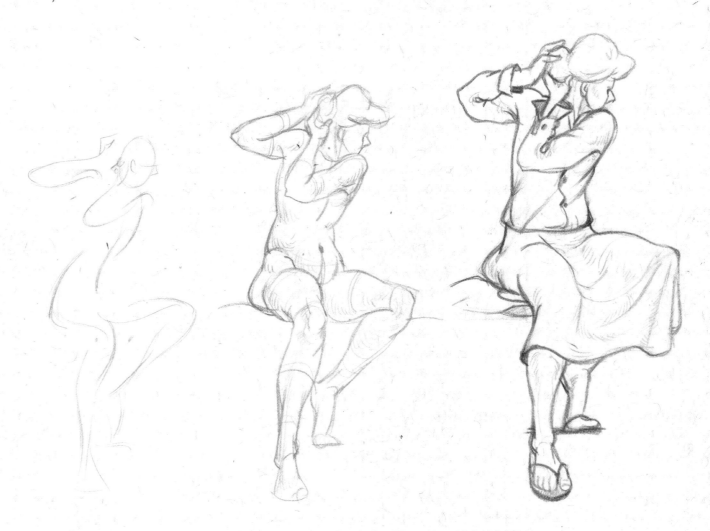

1| Start With a Gesture
The gesture is the foundation of all drawing. Notice the implied twist in the torso.

2| Define the Three-Dimensional Form
You don't have to render the nude form as detailed as I have here, but you do need to define the volumes as they relate spatially. Draw lightly at this stage so the lines fade into the background once the clothes are defined.

3| Add the Clothes
Keep in mind both the gesture and the volumes as you define the clothes. Notice how the folds in the waist still retain the twist established in the gesture stage. Drawing the swag folds between the legs would have been difficult without first defining the forms they rest on.

Chapter Five

EXPRESSIONS

When we look at another person, we usually look first at his or her face. Not only is it how we identify that person, but it is also how we try to determine whether he or she is angry, sad, elated, disgusted or mischievous. It will show in facial expressions. Even an expressionless face means something depending on the context that person is in. Facial expression is such an important part of getting a viewer to connect with an image that it can't be neglected.

It is so important to draw people going about their daily lives because they are real people who are constantly expressing genuine emotion. Though the model is good for study, there is no substitute for the real thing (even an actor can only replicate or accentuate an expression).

"Drawing is ... not an exercise of particular dexterity, but above all a means of expressing intimate feelings and moods."
— Henri Matisse

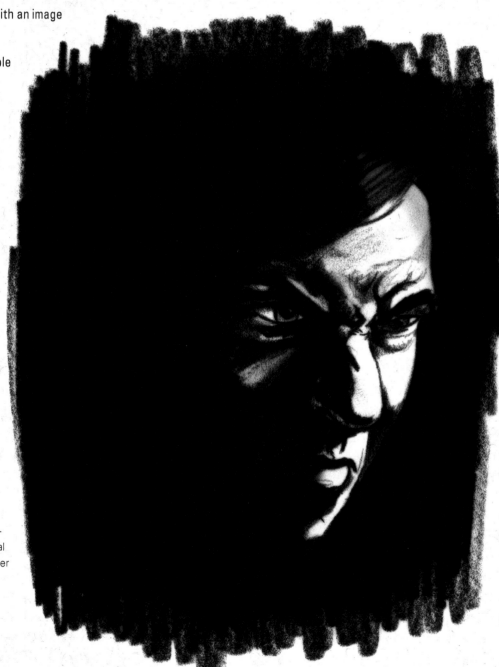

EXPRESSION ADDS INTEREST TO A DRAWING
Portraits may depict what someone looks like, but they don't draw the viewer in emotionally. Expression reveals feelings that the audience can relate to. By juxtaposing expressions of anguish, fear and worry in this drawing, the viewer is drawn into the mental state of the subject, leaving the viewer to wonder what happened.

SIMPLIFIED EXPRESSIONS

I think the face is often neglected because we're focused on getting the body and the clothes right, and the expressions change so rapidly. The face may be an afterthought to us, but it is the first thing the audience looks at.

Because it's impossible for anyone to hold an expression for more than a few moments, you need to learn to capture them quickly and simply. Practicing expressions is fun. You can use a mirror or the reference photos on pages 76–77 to sketch out how the features squash and stretch into recognizable expressions.

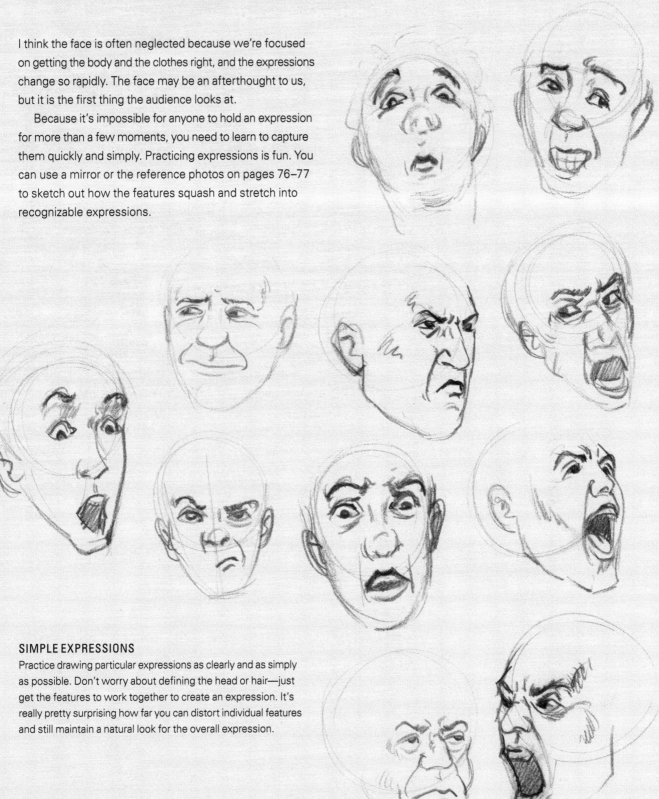

SIMPLE EXPRESSIONS
Practice drawing particular expressions as clearly and as simply as possible. Don't worry about defining the head or hair—just get the features to work together to create an expression. It's really pretty surprising how far you can distort individual features and still maintain a natural look for the overall expression.

GESTURE OF EXPRESSIONS

A person's expression only flashes across the face for a moment, and then it either lessens in intensity or changes. To sketch a genuine expression, the artist has to capture its essence as quickly as possible.

Shown on these pages are a few common expressions. The small drawing accompanying each expression distills the basic shapes of the features with arrows to indicate the direction of energy of each expression. The arrows roughly follow the pull of the muscles, but drawing is more than getting the anatomy correct; you must also capture the overall movement.

In a drawing, a person's expression doesn't stop at the face. The expression's energy should be carried up into the hair, down into the clothing and out into the rest of the drawing. If a woman you are drawing is surprised, so should her hair and her earrings and everything else about her. Everything should conform to the gesture.

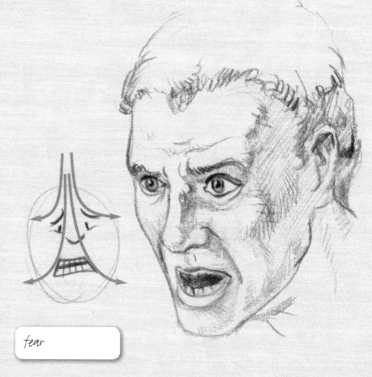

fear

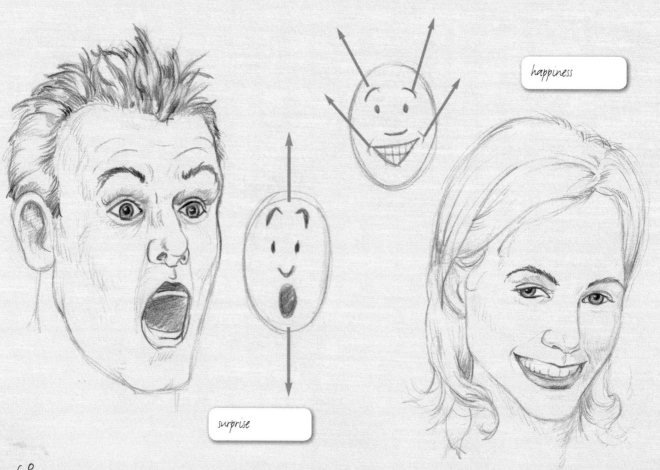

happiness

surprise

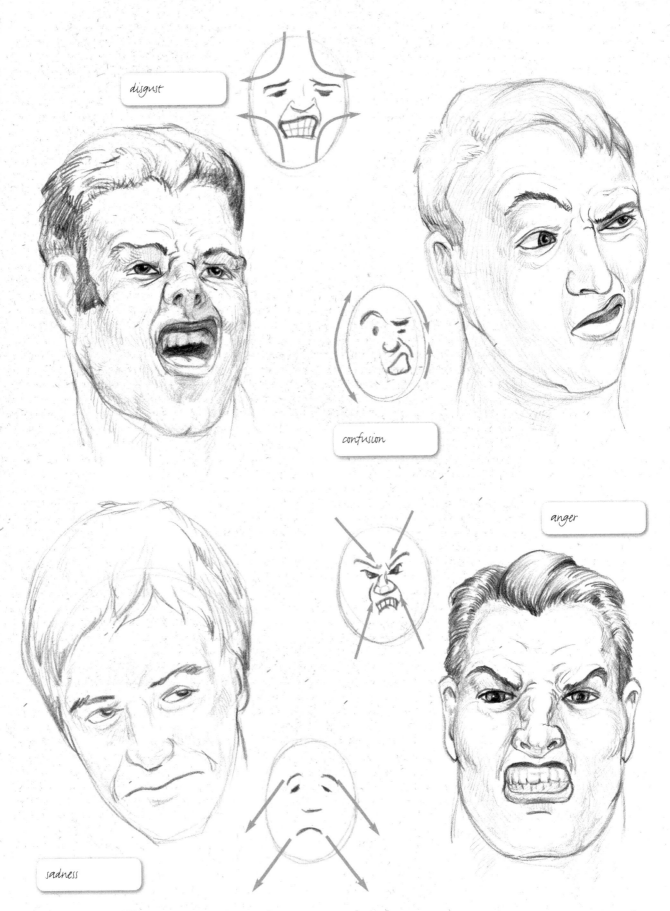

disgust

confusion

anger

sadness

69

GESTURE TO EXPRESSION

When drawing expressions, use the same process: Start with the gesture, build the three-dimensional form, refine the shapes to reflect your specific subject, and, finally, add details. Don't skip the critical gesture drawing or you risk missing the emotion behind the expression.

1| Gesture

Always start with a gesture, capturing both the basic position of the body and the expression in simplified form.

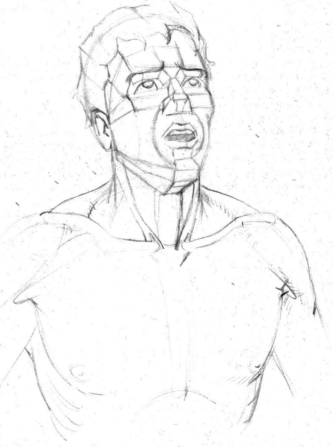

2| Basic Volumes

Go back over the gesture and establish the basic three-dimensional qualities of the figure.

3| Anatomical Forms

Shape the basic volumes into more specific forms that more accurately describe your particular subject.

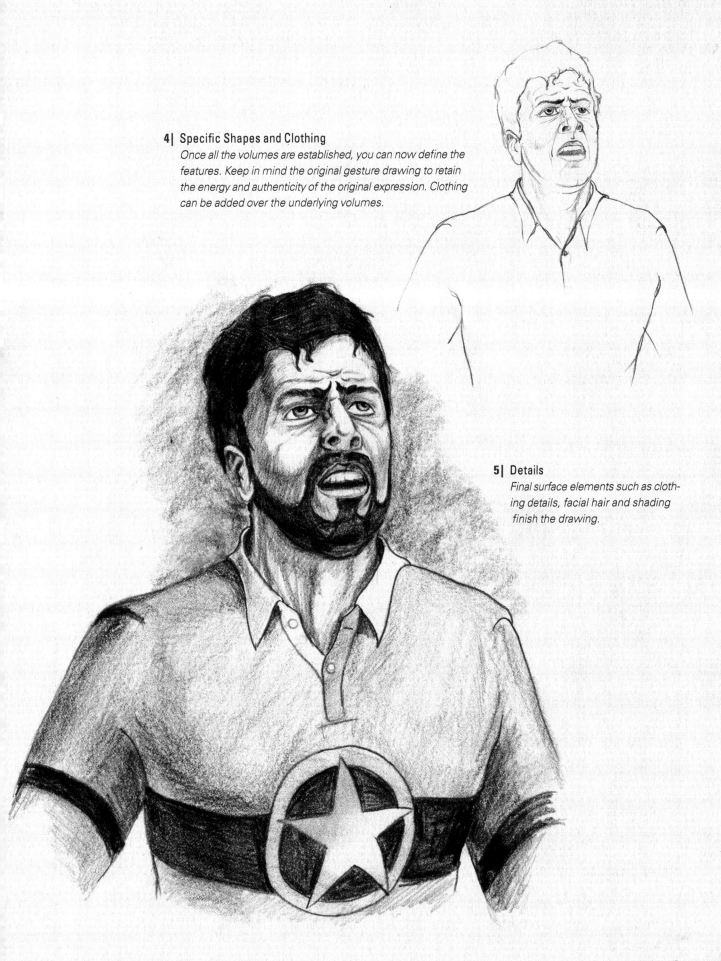

4| Specific Shapes and Clothing

Once all the volumes are established, you can now define the features. Keep in mind the original gesture drawing to retain the energy and authenticity of the original expression. Clothing can be added over the underlying volumes.

5| Details

Final surface elements such as clothing details, facial hair and shading finish the drawing.

SKULL

The skull is the foundation of the head. It's the solid form that the dynamic muscles and skin slide over to create expressions. The eyeball sits in a rigid socket that doesn't move. The bridge of the nose stays firmly in place as the nostrils flare and stretch. The jaw may hinge, but the teeth and muzzle don't move as the lips do. Because of this, to successfully draw expressions, you'll need to be able to draw the skull.

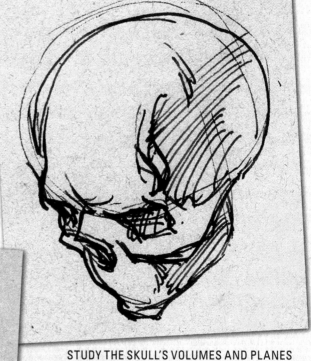

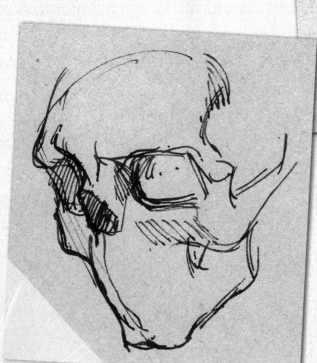

STUDY THE SKULL'S VOLUMES AND PLANES
While some areas are simplified on these two skulls, the volumes and planes are clearly established. Knowing how the skull is built is important when drawing a face because it provides a firm underpinning for the features to hang on.

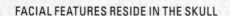

FACIAL FEATURES RESIDE IN THE SKULL
The thin skin on this gaunt face really shows the importance of understanding the skeletal structure when drawing the head. The sunken eyes show how they sit in their sockets and the cheekbone, bridge of the nose and muzzle are quite prominent.

SIMPLIFIED FORM

The simplified head is the basic three-dimensional form without any of the features defined. It shows the general shape, proportion and characteristics of a head and serves as a foundation for the features to be developed on top of. From this base, the features can squash and stretch into a variety of expressions and still retain their solid three-dimensional appearance.

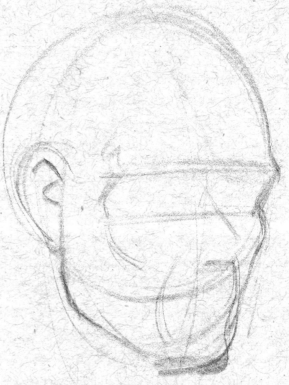

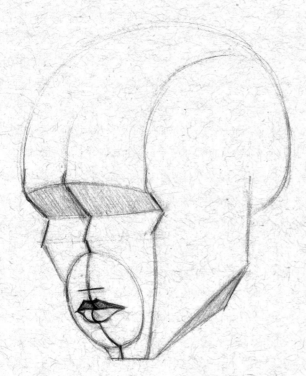

DEFINING PLANES
This simplified head (top right) shows how the basic planes of the forehead, brow, ears, nose, mouth, cheeks and chin relate to each other and fit together on the larger skull.

USE FORMS THAT CONVEY THE ANATOMICAL SHAPES
Notice the bowl shape used for the mouth area (above). This form correlates to the structure of the muzzle on the skull and is made more pronounced by the muscles around the mouth.

MOLD THE GENERAL FORM TO YOUR SPECIFIC SUBJECT
The simplified head (right) comes in different shapes, depending on the subject. This head and jaw is more squared off as you might find on a more stout man (right).

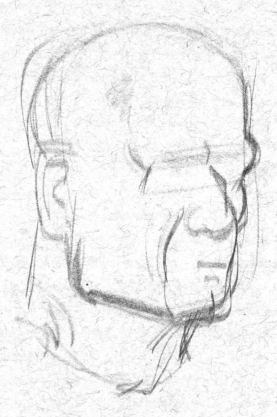

HAIR: SHAPE FIRST, DETAILS LAST

Hair is so much a part of a person's character, but drawing it is often a challenge. The problem often results from looking at the texture of individual hairs rather than capturing the overall shape first. Just as in all the other drawing we have been doing, you first need to define the total volume before the details can be developed. Remember that the shape of the hair should be altered to conform to the overall gesture. When adding detail to the shape, think about groupings of hair rather than individual strands.

HEAVILY STYLED

This hair has gained volume through styling. Show natural airiness by letting the hair fall into forward-sweeping groupings. Rendering too many strands could weigh down the body of the hair.

THINNING HAIR

The receding hair begins close to the forehead and grows thicker as it moves farther back. The areas of thicker hair are rendered darker to give them a sense of mass, and contrast with the lighter, thinner hair on top.

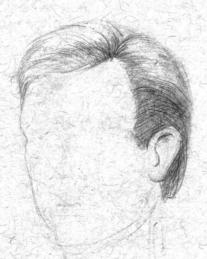

LIGHT REFLECTIONS

This hairstyle uses a glossy gel to purposely emphasize the combing pattern and shape. The areas where light shines off the hair are left largely white with only a few strands to break up the pattern.

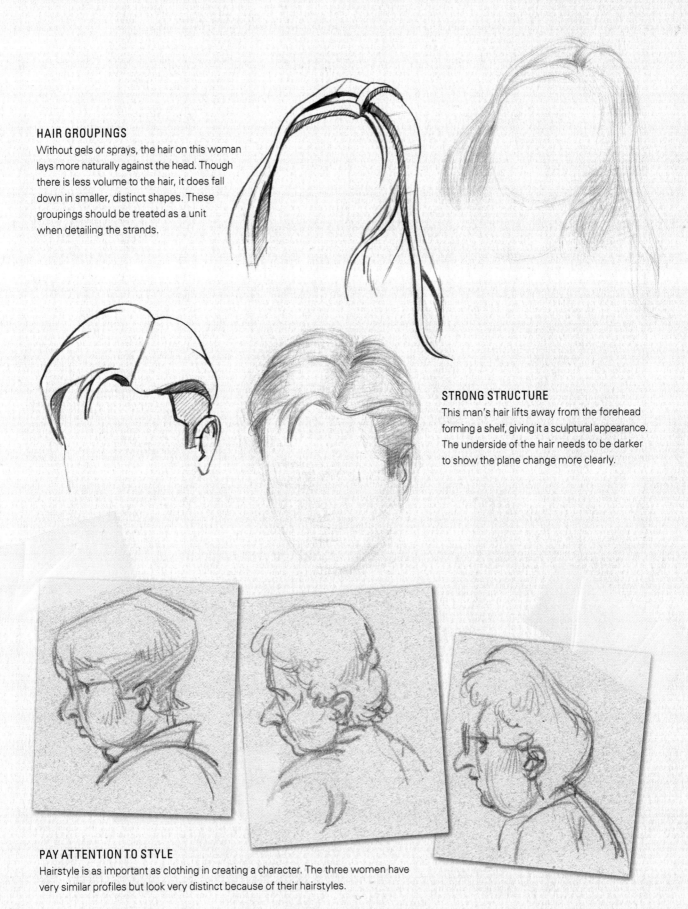

HAIR GROUPINGS

Without gels or sprays, the hair on this woman lays more naturally against the head. Though there is less volume to the hair, it does fall down in smaller, distinct shapes. These groupings should be treated as a unit when detailing the strands.

STRONG STRUCTURE

This man's hair lifts away from the forehead forming a shelf, giving it a sculptural appearance. The underside of the hair needs to be darker to show the plane change more clearly.

PAY ATTENTION TO STYLE

Hairstyle is as important as clothing in creating a character. The three women have very similar profiles but look very distinct because of their hairstyles.

EXPRESSION REFERENCE PHOTOS

These photos demonstrate how dramatically the features can change shape. You can't just learn how to draw an eye, nose or mouth—you have to understand how to mold the features into expressions.

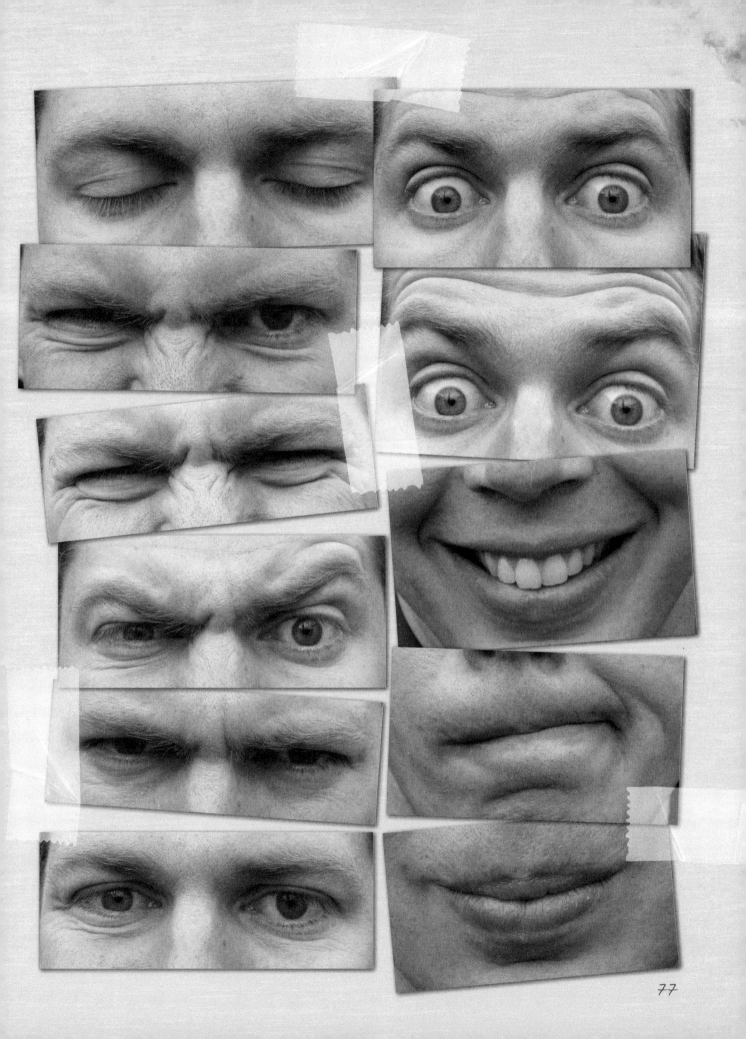

77

Chapter six

BODY LANGUAGE

Drawings begin to take on a life of their own when a figure begins to act out emotions. The viewer no longer notices the lines, forms and shades that create the drawing, but instead gets involved with what the character is doing and thinking.

Because the body reacts more subconsciously, it may reveal feelings in the subject that the controlled face conceals. It becomes quite obvious what a person is thinking when, for example, the face is smiling but the arms and legs are crossed and the body is turned away from another person. This unwelcome message wouldn't be detected by just looking at the facial expression, and it adds depth to the character and gives a sense of a story. What caused these feelings, and why are they being hidden?

Most poses are not held for very long and are one part of a chain of motion. The pose to pick in any fluid action by your subject is the one that is most iconic for the emotion being expressed.

"The foulest, the vilest, the obscenest picture the world possesses—Titian's Venus. It isn't that she is naked and stretched out on a bed – no, it is the attitude of one of her arms and hand."
—Mark Twain,
A Tramp Abroad

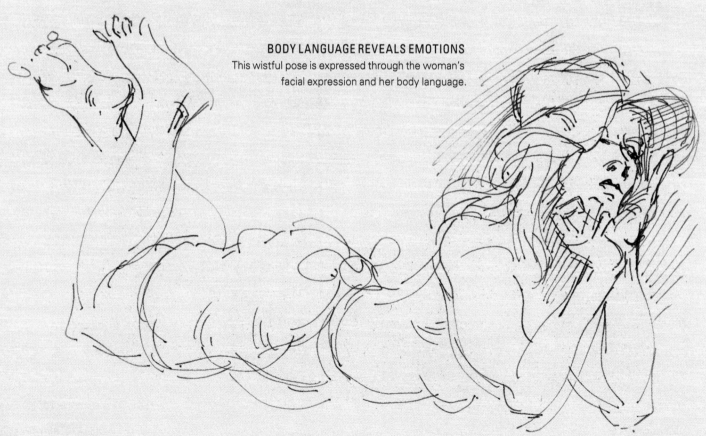

BODY LANGUAGE REVEALS EMOTIONS
This wistful pose is expressed through the woman's facial expression and her body language.

ICONIC POSES

While body language is not an infallible guide to what someone is thinking, certain body positions convey certain universal messages. We immediately recognize an aggressive stance, and we can infer some of what is on that person's mind. You can enhance these postures to give your subject attitude that clearly communicates to the viewer.

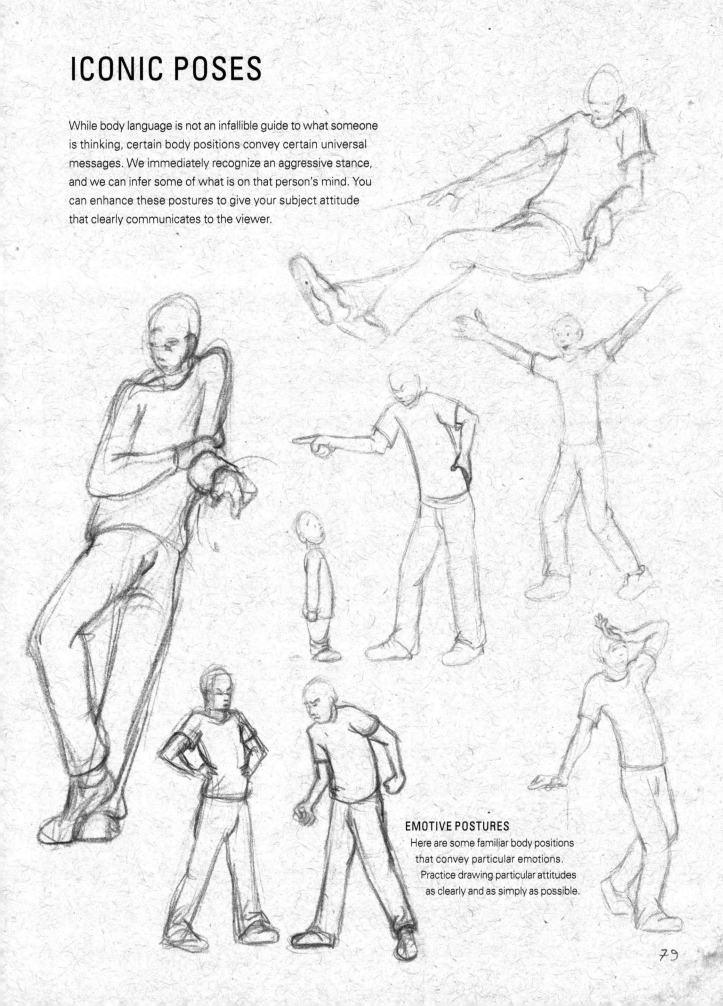

EMOTIVE POSTURES

Here are some familiar body positions that convey particular emotions. Practice drawing particular attitudes as clearly and as simply as possible.

79

CATEGORIZING POSES

Though a subject can have a seemingly infinite number of
postures, an artist should look for some broad character-
istics that project certain traits. Following are a couple
of contrasting characteristics (open vs. closed poses,
and poses where the figure is leaning in vs. leaning away)
that demonstrate how engaged the subject is with his or her
surroundings. Looking at the body language gives you clues
about what's on your subject's mind. You can then strengthen
that body language in your drawing to better communicate it
to the audience. For example, if you see someone with
a very closed pose, he probably seems to be feeling vulnerable;
you can heighten that message by exaggerating that posture,
expression and staging in your drawing.

OPEN POSES

Open poses are characterized by extended arms, hands and
legs and a lifted head. But more than the specifics of body posi-
tion, any posture that is open conveys that people are engaging
the world and trying to communicate with those around them.
They can be expressing anything from friendliness to arrogance
to compassion to rage, but the commonality is that they are
interacting with their surroundings.

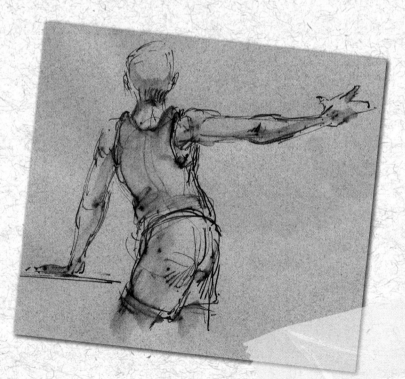

OPEN POSES
Despite the differences in attitude between
the confrontational man in the tank top and
the Native-American man acting out a spiritual
ritual, you can see by their postures that they
are both open to connecting with someone or
something outside of themselves.

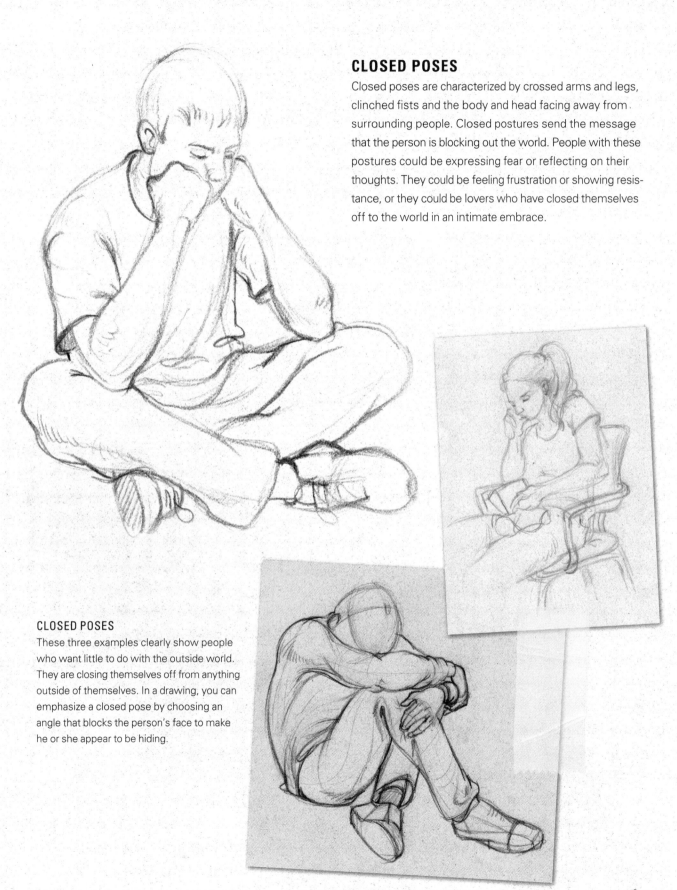

CLOSED POSES

Closed poses are characterized by crossed arms and legs, clinched fists and the body and head facing away from surrounding people. Closed postures send the message that the person is blocking out the world. People with these postures could be expressing fear or reflecting on their thoughts. They could be feeling frustration or showing resistance, or they could be lovers who have closed themselves off to the world in an intimate embrace.

CLOSED POSES

These three examples clearly show people who want little to do with the outside world. They are closing themselves off from anything outside of themselves. In a drawing, you can emphasize a closed pose by choosing an angle that blocks the person's face to make he or she appear to be hiding.

LEANING IN

If a person is leaning in toward whatever he or she is engaged with, he or she is expressing interest in what is happening. Whether executives discussing a deal, a boy exploring a bug on the ground or a concerned friend at dinner, leaning in shows real interest in what is going on.

LEANING AWAY

Leaning away shows disinterest in what is happening. The student at the back of the room leaning back in a chair dreaming of summer is not interested in the teacher's math lesson. Leaning away can be a way of relaxing, not resisting as a closed pose might be, but a way of disconnecting from the surroundings.

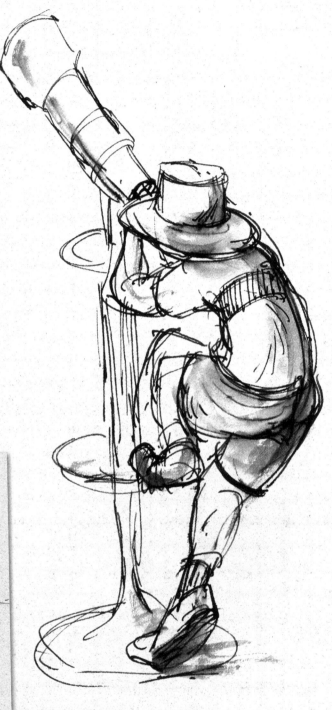

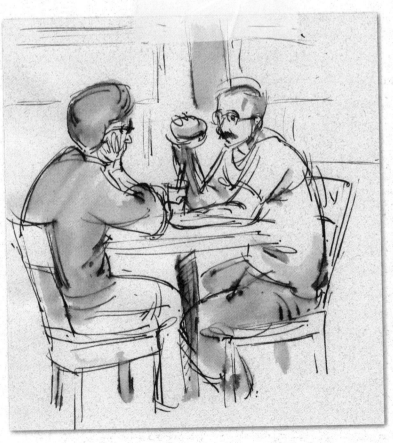

LEANING IN

You can see that the couple eating together is engaged in conversation because they are leaning in toward each other. It shows they are interested and are paying attention. The boy using the telescope is really leaning over to peer into the eyepiece; he's clearly enthusiastic about what he's doing.

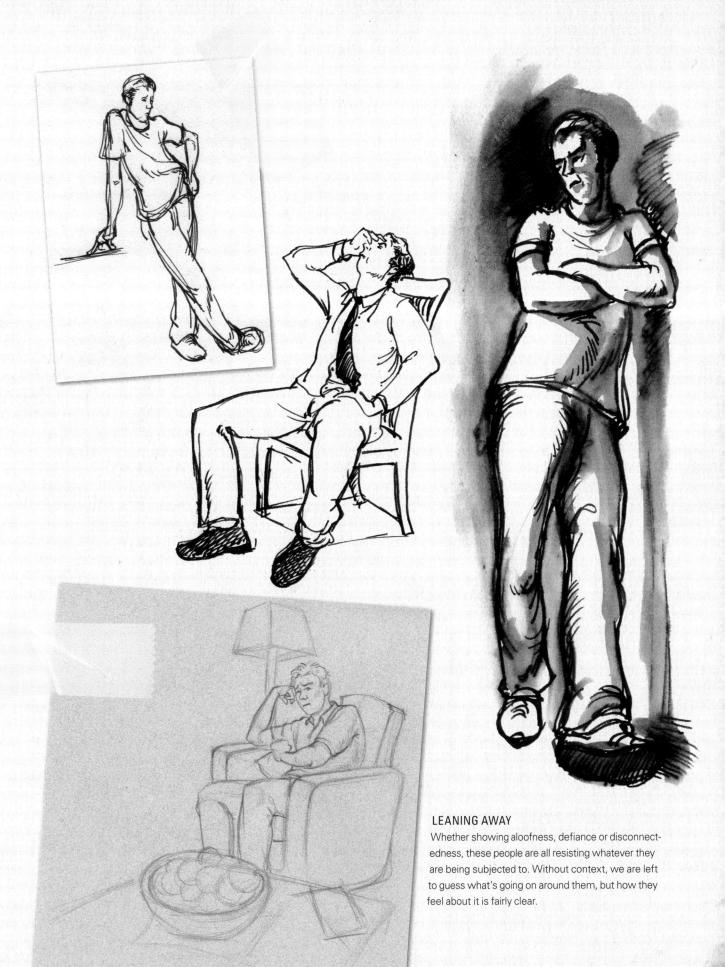

LEANING AWAY

Whether showing aloofness, defiance or disconnectedness, these people are all resisting whatever they are being subjected to. Without context, we are left to guess what's going on around them, but how they feel about it is fairly clear.

DEALING WITH SYMMETRY

People sometimes position themselves in a symmetrical pose. When drawing them, it's better to alter the position of their arms and legs so each side doesn't mirror the other. We naturally tend to design symmetrically, but things are far more interesting to look at if they aren't uniform. If symmetry is important to the pose, approaching it from an oblique angle will make it more interesting.

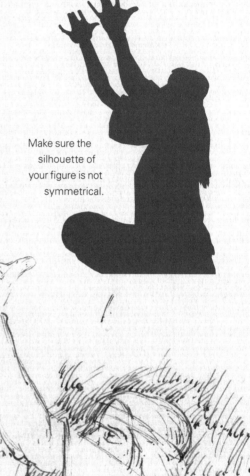

Make sure the silhouette of your figure is not symmetrical.

THREE-QUARTERS VIEW
In both of these examples, the model is sitting in a symmetrical position. If the drawing had been from the front, each side would be a mirror of the other. By moving to a three-quarter view, the silhouette is not symmetrical, even though the pose is.

DEVELOPING THE POSE

The best way to develop a pose is to do as an actor would: Become a character, adopting his or her mind-set and feeling that character's mood. Let it grow up from your toes, through your legs, expanding through your torso and out to your arms, letting the character wash over your head and take over your whole body. Notice what posture you've naturally adopted as you've done this. Don't force yourself into what you think the pose should be, but let yourself naturally feel it out as if you were that person.

This also works in reverse. If you see someone in a pose, take it yourself to get a sense of how it makes you feel. This works because our minds seem to be instinctively influenced by our postures; this will tell you how to approach the drawing. Do you feel angry or fearful when you adopt the pose? Your subject is probably feeling that way, too. Draw with that same passion.

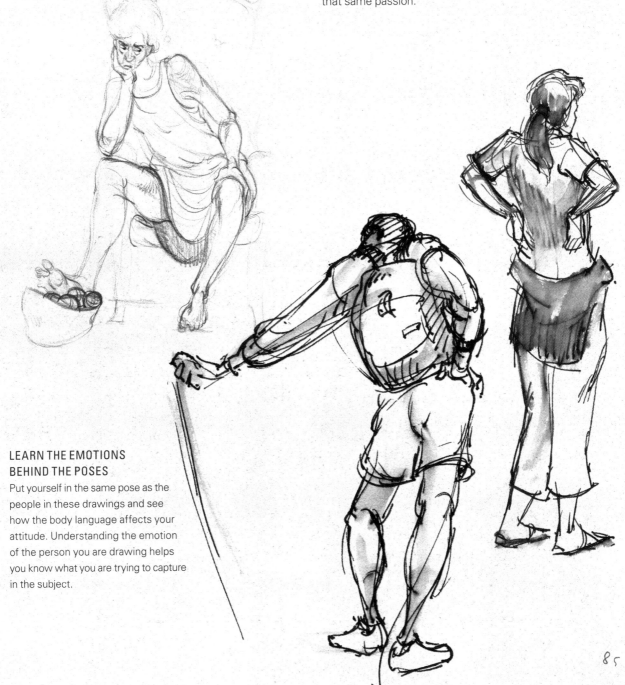

LEARN THE EMOTIONS BEHIND THE POSES

Put yourself in the same pose as the people in these drawings and see how the body language affects your attitude. Understanding the emotion of the person you are drawing helps you know what you are trying to capture in the subject.

85

HANDS

Our hands are designed to be useful tools for grabbing and manipulating objects, but when they don't have work to do they become powerful agents of expression. When someone is angry, hands may clench, ready to fight. When someone gets excited, hands may gesture about with enthusiasm. How someone positions his or her hands also reveals character; an aristocratic woman may daintily flair out her pinky when drinking from a delicate coffee cup and would be totally different from a short-on-time mother grabbing a mug of coffee on her way out the door. Depict your subjects' hands in a way that enhances their body language and strengthens the clarity of their emotions.

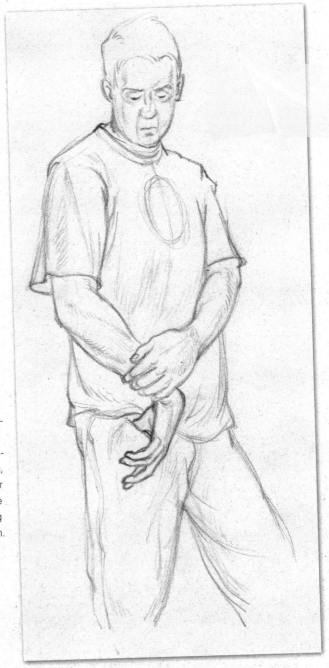

FACE TOUCHING
People often touch their faces, particularly when they are thinking or are nervous. The hand becomes part of the facial expression. In this drawing, notice how the finger reflects the arch in the eyebrow, enhancing the expression.

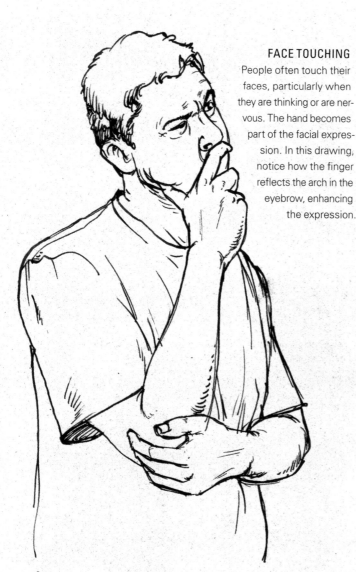

HANDS AND BODY LANGUAGE
The arms drawn across his front and his averted gaze show a closed body position. His hands reflect this larger pose—closed off, almost trying to hide. Additionally, both his pose and his hands are relaxed, telling us that he may be reticent but is not fearfully shy.

HANDS: BEGIN WITH GESTURES

Because of the dexterity of the fingers, hands can take a wide variety of poses. Their dynamic gestures and subtle poses punctuate the body's message. It's easy to get too wrapped up in the details, but if you focus on the minutiae it will appear disconnected from the rest of the drawing. As always, the whole drawing needs to develop first from a gesture. In the initial stages, keep the hands as simple as possible, focusing more on the feeling of the gesture rather than the anatomical shapes of the form. As always, start with a gesture, then develop the volumes and finally add details.

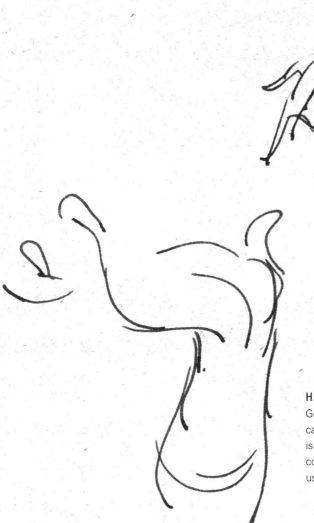

HAND GESTURES
Gestures quickly set up how parts relate to each other. The lines can reflect contours or centerlines but are neither. The sole purpose is to quickly create a foundation that shows how all the parts relate, connect and integrate into each other that can later be developed using basic forms.

HANDS: CONSTRUCTION

Once the gesture has been established, you can use basic forms to begin to develop the three-dimensional qualities of the hands. It's important to not get caught up in anatomy or shading until you have defined the overall shape. Be very aware of the gesture as you develop the form because it will help to ensure that the parts still integrate into the whole, but don't be afraid to modify the gesture as you define and refine the overall form.

BOX SHAPES
I like to use box forms to develop the hands because they are better equipped to show the correct way the knuckles bend. The angular forms also lend themselves to a more powerful appearance.

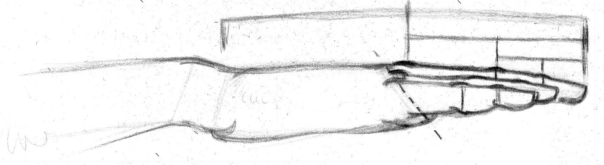

HAND PROPORTIONS
The first knuckle is half the distance from the wrist to the tip of the finger. The second knuckle falls halfway between the first knuckle and the tip of the finger. The third knuckle is again half the distance between the second knuckle and the tip of the finger.

USE BOX SHAPES TO GET THE CORRECT ANGLES
The box forms help to get the angles and proportions correct. The bones are close to the surface on the tops of the fingers, making the knuckles apparent under the skin.

HANDS & EXPRESSION

Only once the three-dimensional form is clear should you begin to develop the anatomical details like nails, knuckles and pads. If you have been faithful to the gesture, the final details will retain the initial expression you captured in the gesture. Your goal should be the expression, not the anatomy. An understanding of anatomy can help convey the expression, but knowledge of anatomy will do nothing in creating expression if you don't capture it in the gesture.

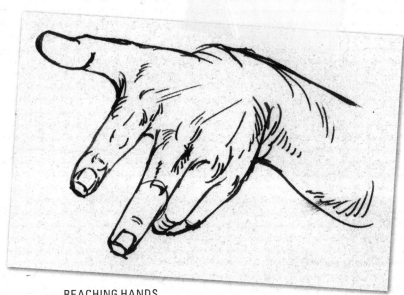

REACHING HANDS
The outstretched fingers reach toward the viewer but two fingers tuck back, showing that the person has some hesitation.

WRENCHING HANDS
The two hands tightly clasped are a manifestation of some anguish the person is going through.

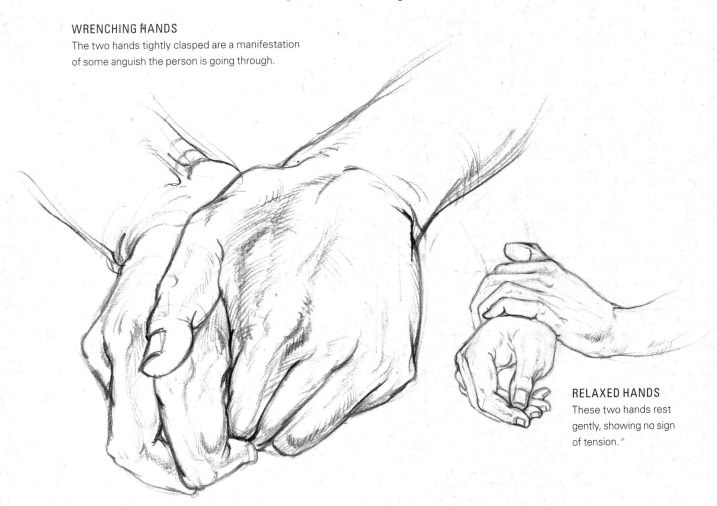

RELAXED HANDS
These two hands rest gently, showing no sign of tension.

Chapter Seven

STAGING

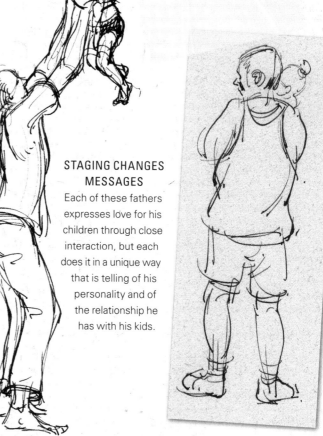

For a visual artist, choosing how to depict an event—what parts are emphasized and what are downplayed, the angle the scene is depicted from, how close the viewer is brought to the action—is done through staging. If there are enough clues through the interplay of body language, setting, costumes, props and even artistic style, the viewer will understand the story and the meaning behind it.

The relationships we have with the people around us tell us about who we are and help define our roles in life. How each individual goes about fulfilling that role is unique to his or her personality. Two people in the exact same situation will act differently; this says something about who they are.

We can tell a lot about someone's inner character by how that person behaves in certain situations. It's an external way to see someone's internal thoughts and beliefs. A person's body language, expression and appearance only give a partial glimpse of who he or she really is; it is through the context of his or her relationships with other people that we begin to understand that person's true character.

Some might be put off by a scruffy, tattooed, leather-clad biker, but if they were to witness him assisting an elderly woman with a flat tire or his tenderness toward a kitten, the stereotypes his gruff appearance gives off would be shattered. His actions make us see him as an individual. Portraying these authentic interactions that take us beyond appearance and into the person as an individual is what we need to aim for if we want to capture something meaningful in our art.

STAGING CHANGES MESSAGES
Each of these fathers expresses love for his children through close interaction, but each does it in a unique way that is telling of his personality and of the relationship he has with his kids.

"*The artist must fulfill two goals: the honest expression of human relationships and the presentation to the viewer.*"
—Steven D. Katz

CHARACTER & SETTING

Setting and props are often used as just a backdrop to give characters a sense of place, but setting and props also give us a sense of character by showing us how a person is behaving in his or her surroundings. An aggressive posture is noticeably out of place inside a cathedral and reveals something very different about the character than if he were in a run-down bar. If you were to draw this scene, you might choose to render the sublime architecture of the church in all its detail and grandeur or simply give the man a Bible to hold while he's chiding another parishioner.

IN YOUR SKETCHBOOK

When you are out drawing real people in real settings, people will be moving around too much for you to quickly capture the whole scene at once. There are two approaches that will help you capture everything. The first is to develop the setting, then draw individual people as they come and go in the setting. Your finished sketch won't depict a singular moment like a photograph would, but a scene you design from an amalgamation of several moments. The second approach is to develop a setting around a figure you've already established. This second approach gives you some flexibility as to the character's setting, allowing you to take a sketch done at one location and transport that character to an entirely different setting. For example, if you had a sketch of an older gentleman leaning on a cane, you could place him in the park where you sketched him or on a stage. You can see how setting changes the character; one setting makes the old man seem lonely and isolated while the other makes him the star of a show. Try this yourself by taking a drawing you've done of someone and developing a different setting around him than where you originally sketched him. Think about an appropriate place where this person and his body language, expression and clothing would seem natural. Don't just plop him down in some random scene; choose a setting that reveals something about the character, a place that enhances who he is.

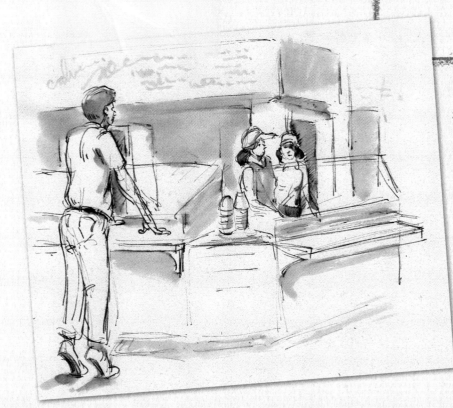

SETTING AND STAGING WORK TOGETHER

This man is trying to get the attention of the two women behind the counter. The setting not only gives a sense of place but also helps the audience understand the roles of the characters. Plus, the way the drawing is staged lets the viewer see the event from the customer's side, looking at the unresponsive employees in the distance. Though it isn't a complex story, the staging and setting show us a story we all have had experience with.

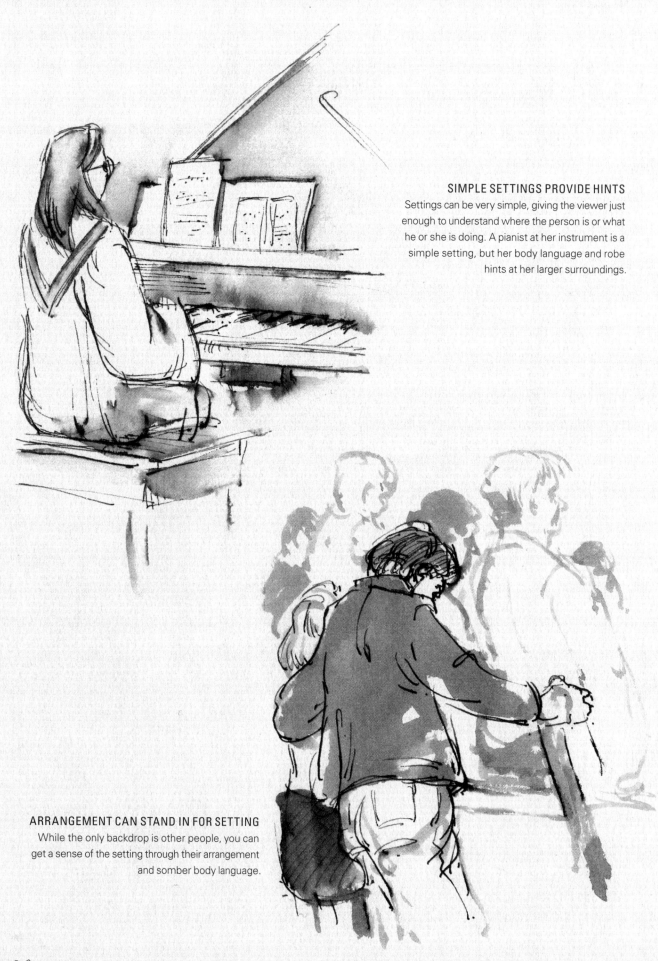

SIMPLE SETTINGS PROVIDE HINTS

Settings can be very simple, giving the viewer just enough to understand where the person is or what he or she is doing. A pianist at her instrument is a simple setting, but her body language and robe hints at her larger surroundings.

ARRANGEMENT CAN STAND IN FOR SETTING

While the only backdrop is other people, you can get a sense of the setting through their arrangement and somber body language.

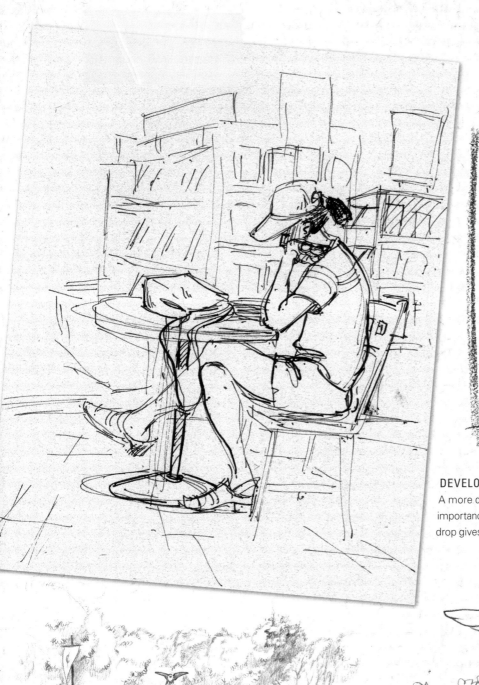

DEVELOPED SETTINGS STRESS LOCATION

A more developed setting would emphasize the importance of location to the scene while a basic backdrop gives the figure in the scene a sense of place.

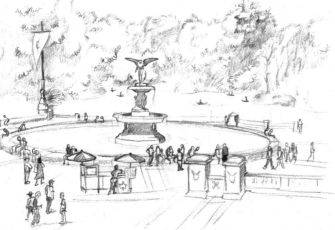

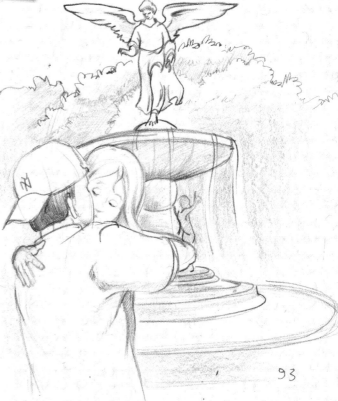

STAGING CAN CHANGE AN ENTIRE DRAWING

While the setting is the same in these two drawings, the staging is different. One is about the setting while the other is an intimate moment.

93

CHARACTER BLOCKING

Character blocking is how people are staged in relation to each other. At its most basic, character blocking is always between two people. Even if additional characters are in the scene, each pair is blocked individually. The only exception is where there is a distinct contrast between your main character and a group; for example, in a scene with a protester standing in front of a line of riot police, the protester could be blocked in relation to the group of police as a single whole.

Although it is impossible to represent all possibilities, these four pages show some of the most common variations in character blocking. Positioning the characters will be combined with vantage point and proximity.

FACING AWAY

When two people are together but are facing in opposite directions, they are often attempting to shut the other person out without abandoning them completely. It's a way to hide emotions by not showing facial expressions and body language. Your characters don't have to be back-to-back to express this emotional distance, just looking away from each other is enough.

FACING

Whether they are sitting across the table from each other at a relaxed dinner or standing toe-to-toe in a confrontational argument, people who are facing each other are focusing their attention on just one other person.

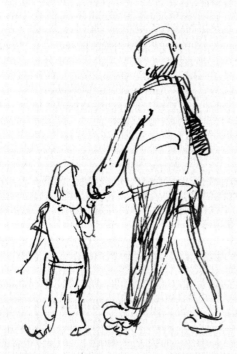

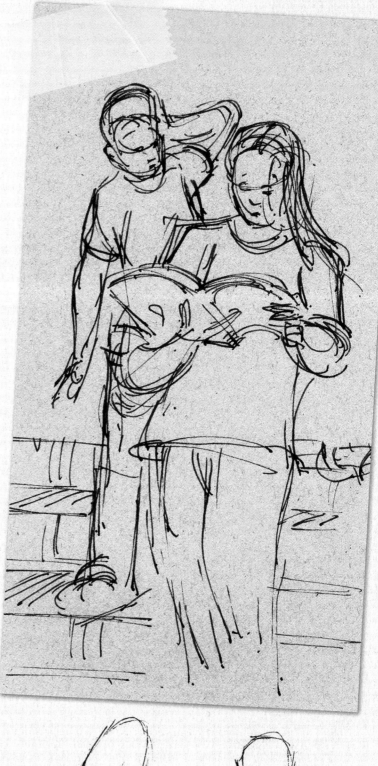

LINED UP

People line up for a number of reasons: standing in a line, trying to talk to someone who has turned his back, sneaking up on someone, or, as in this sketch, leaning over someone's shoulder to see what she's looking at, are a few examples. Often the person in front doesn't know what's really going on behind her, either because she trusts the other person enough to not have to watch him or because she's unaware of the other person's presence.

SIDE BY SIDE

Being side by side is a natural position for walking or sitting together (i.e., on a bench, couch or in the audience of some event). It shows a comfort with the other person and that he or she is trusted to not have to be watched all the time.

ANGLED

An angled pose allows the characters to be close without having direct eye contact. One situation where this position occurs is when two people want the closeness to discuss emotionally difficult topics without invading the other's suffering by looking him in the face.

L-SHAPED

Similar to an angled pose, the two individuals are not sharing eye contact, but here one is directly facing the other. The person looking is trying to connect, and the other is trying to get a little distance without going so far as to turn his back entirely.

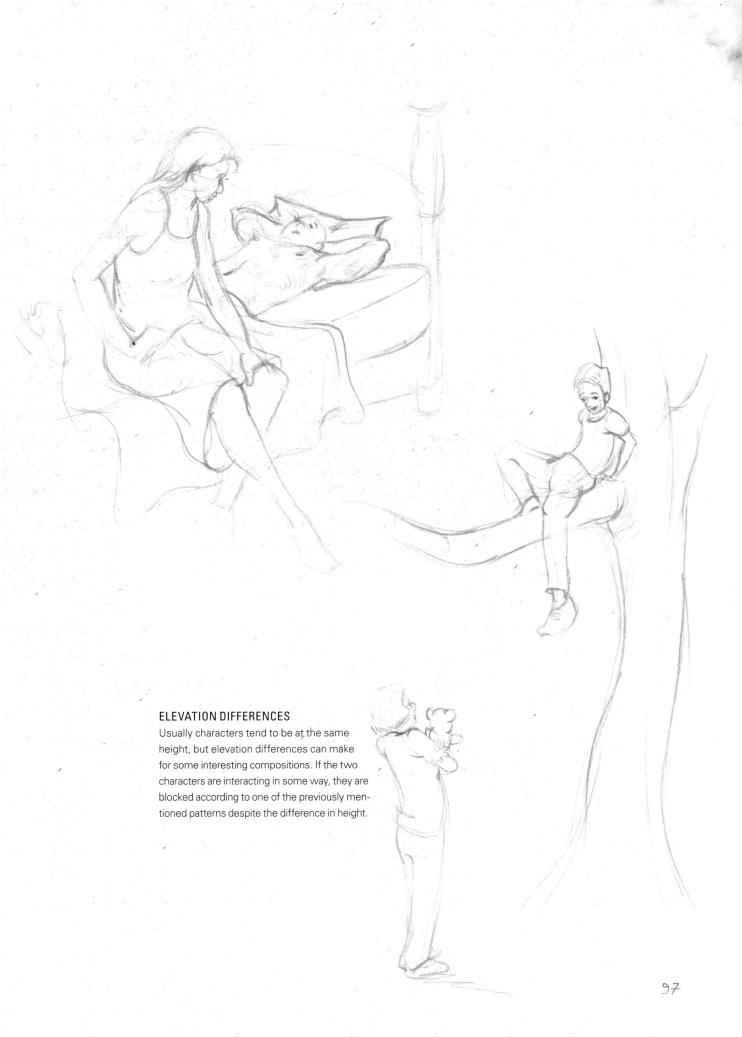

ELEVATION DIFFERENCES

Usually characters tend to be at the same height, but elevation differences can make for some interesting compositions. If the two characters are interacting in some way, they are blocked according to one of the previously mentioned patterns despite the difference in height.

VANTAGE POINT

The vantage point is the angle at which you draw the image
and it becomes the viewer's point of view. How you depict
the scene has no bearing on how the characters are blocked.
If people are standing side by side, you can choose an angle
from the front, the back, the side, from a very high or low
angle, from behind one person or even from the point
of view of one of the characters, just to name a few.

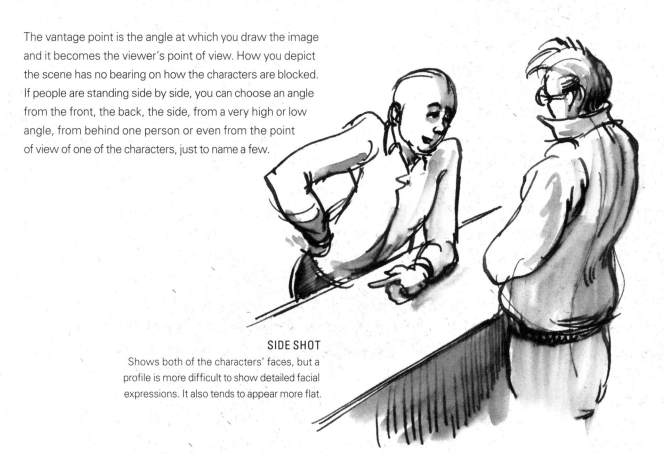

SIDE SHOT
Shows both of the characters' faces, but a
profile is more difficult to show detailed facial
expressions. It also tends to appear more flat.

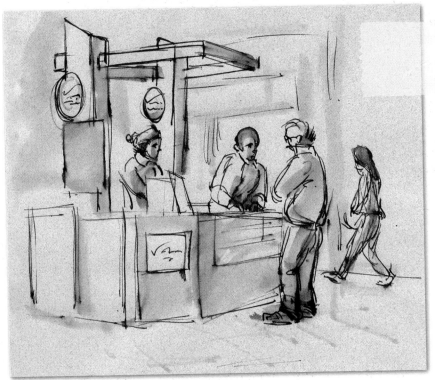

FROM THE SIDE
This drawing of a kiosk in the mall is from
my sketchbook. I chose to establish the
whole scene showing the booth and the
customer facing two lined-up salespeople.
My vantage point was from the side, but
I could have moved or drawn from my
imagination other angles to depict the
same scene.

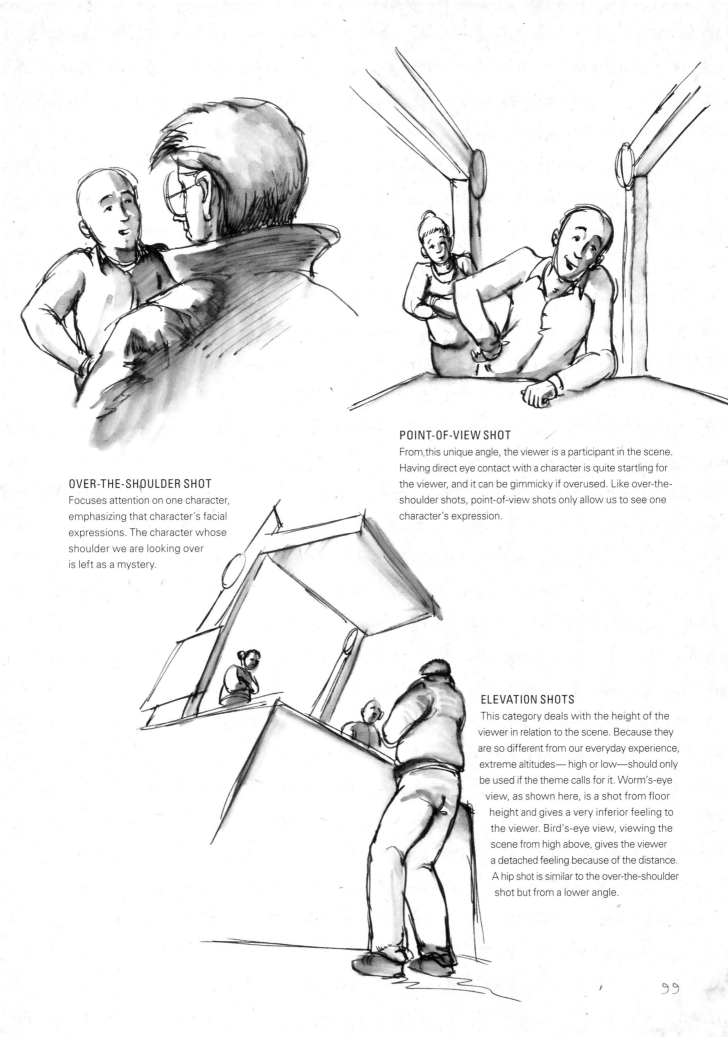

POINT-OF-VIEW SHOT

From this unique angle, the viewer is a participant in the scene. Having direct eye contact with a character is quite startling for the viewer, and it can be gimmicky if overused. Like over-the-shoulder shots, point-of-view shots only allow us to see one character's expression.

OVER-THE-SHOULDER SHOT

Focuses attention on one character, emphasizing that character's facial expressions. The character whose shoulder we are looking over is left as a mystery.

ELEVATION SHOTS

This category deals with the height of the viewer in relation to the scene. Because they are so different from our everyday experience, extreme altitudes— high or low—should only be used if the theme calls for it. Worm's-eye view, as shown here, is a shot from floor height and gives a very inferior feeling to the viewer. Bird's-eye view, viewing the scene from high above, gives the viewer a detached feeling because of the distance. A hip shot is similar to the over-the-shoulder shot but from a lower angle.

PROXIMITY

Your angle may be predetermined by where you are seated in relation to the events taking place, but you have total control over how close or distant you depict your subject. Decide how intimately you want the viewer to be to the characters and what other elements are necessary to tell the story, and that will determine how you frame your image. The closer the subject is to the viewer, the more connected the viewer will feel.

You will notice that none of the drawings stops on a joint. If you end at an elbow or knee, for example, it might seem as if the subject has an amputated limb. Wherever you stop the drawing, make sure there is an indication that the body continues even though it won't be rendered.

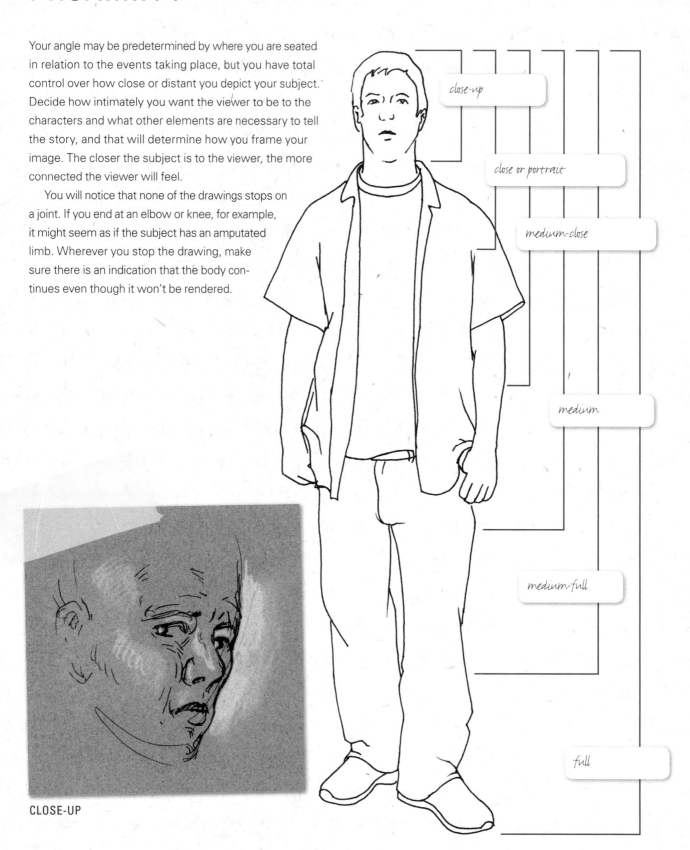

close-up

close or portrait

medium-close

medium

medium-full

full

CLOSE-UP

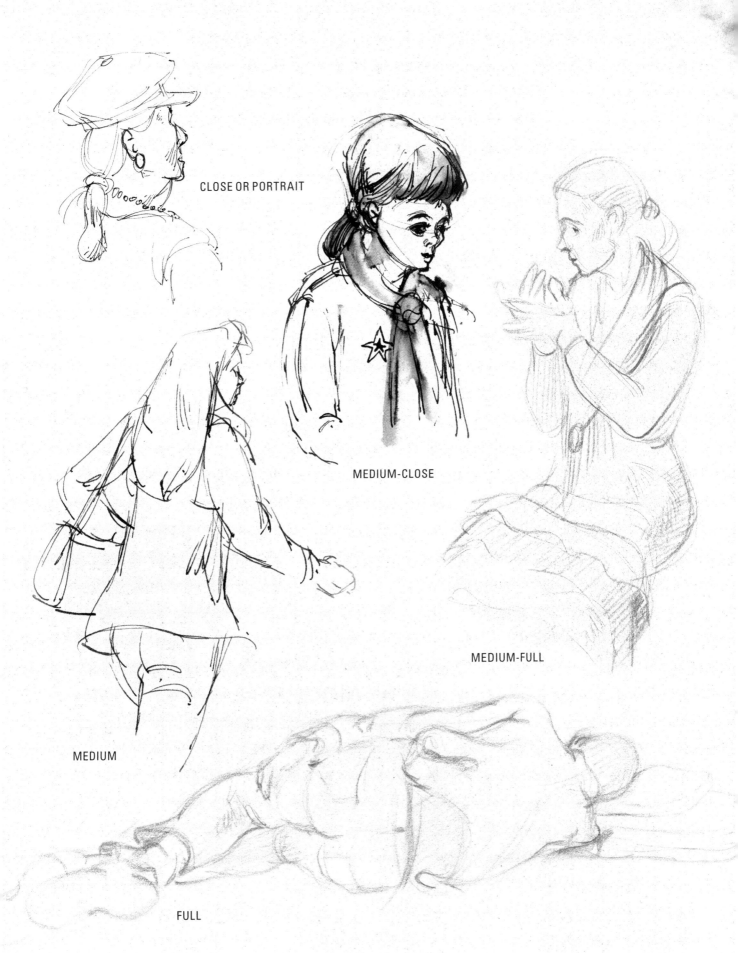

CLOSE OR PORTRAIT

MEDIUM-CLOSE

MEDIUM-FULL

MEDIUM

FULL

SIMPLE STAGING, ONE

A good way to get the hang of staging is to use boxes, spheres or cylinders as subjects. This distills the concept to its simplest form and allows you to practice the dynamics of interaction without having to concentrate on drawing people. You can use these sketches later to substitute people in place of the simple forms.

SIMPLIFY USING BASIC SHAPES
TO GET THE HANG OF STAGING

STORY

The best way to communicate an idea when you are sketching people is to use your subjects to tell a story, because they naturally lend themselves to storytelling.

SIMPLE STAGING, TWO

Place three objects in a scene, in this case a teapot, a teacup and a spoon, on a table, and draw them in a variety of compositions. Any three objects and an appropriate setting will work.

 Keep it realistic. Don't put the kettle in space or surrealistically warp the table or hang the teacup from the teapot's spout. Stick to the exercise and challenge yourself to see how creative you can be with strict guidelines. Play with blocking, vantage point and proximity to create an endless variety of staging possibilities.

 Finally, add a sense of storytelling to the scene. Why are the objects where they are? How did they get there? What is about to happen? Why are we looking at this scene from this angle? What feeling do we get from the scene?

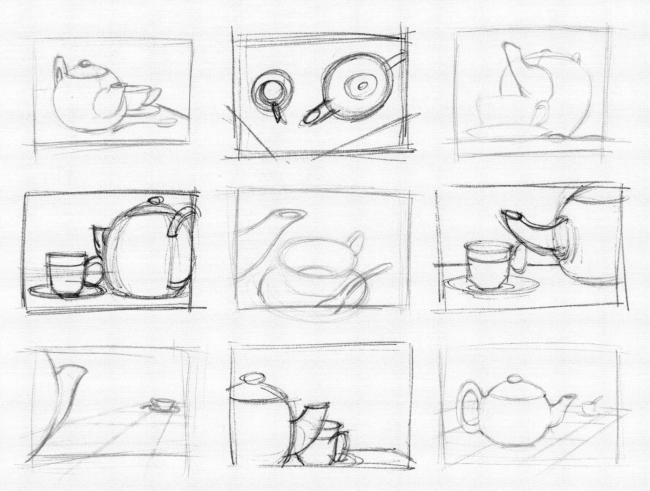

CREATE SIMPLE SCENES USING THREE SIMPLE OBJECTS

STAGING PEOPLE

Staging is a tool to show the audience relationships between people. When sketching, you will take your blocking cues from how the people you are drawing interact. But just as you have to design your characters' appearances, you also have to design the staging to show how your characters feel about each other. Just as with everything else to this point, the drawing has to be influenced by what's really happening, but you aren't copying exactly what you see.

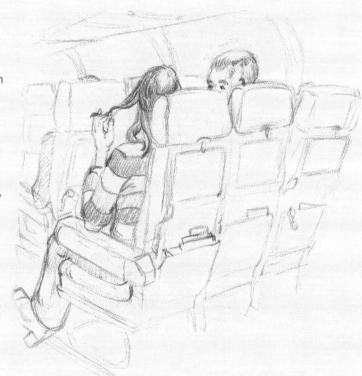

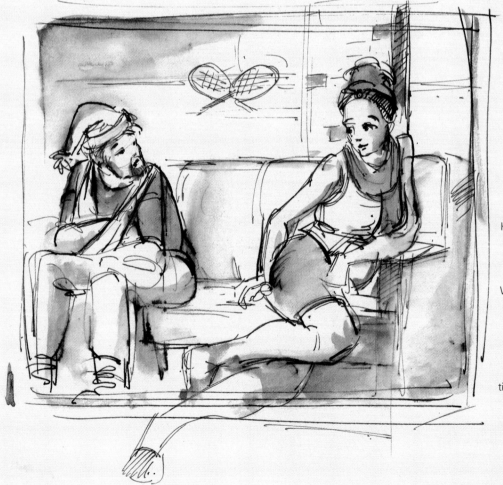

STAGING & VANTAGE POINT
Another story of two strangers meeting, this time on an airplane. Here, the vantage point from behind uses the seats to give them a sense of privacy and intimacy. The staging uses vantage point combined with body language to tell the story.

STAGING TELLS A STORY
Here the costume and setting set the stage in a ski lodge, but the story comes from the two characters' interaction. While both characters' bodies are facing away from each other, suggesting that they are strangers, they share an inviting look that suggests they may be interested in getting to know each other better.

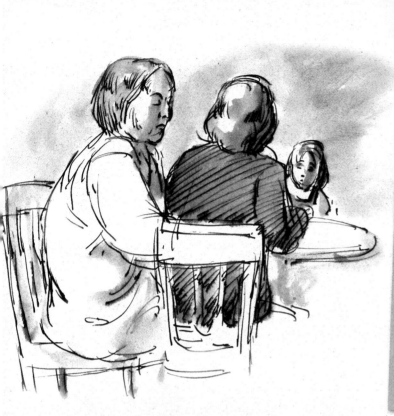

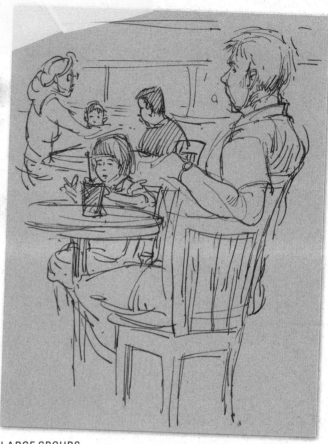

STAGING THREE PEOPLE

When there are more than two people, consider how each person relates to each other. In this sketch, the lady on the left seems formidable, not only by her size but also because of the way the other two characters seem to lean away from her. A secondary relationship is hinted at by the little girl looking to the other woman for support.

LARGE GROUPS

There isn't always a relationship between everyone in the scene, but larger groups are made up of smaller clusters of people who interrelate. In this scene, there are two separate tables of people who have no connection to each other. However, within each group there are relationships that are suggested by the staging. The father who seems to be ignoring his daughter is contrasted with the mother in the background who is interacting with her kids.

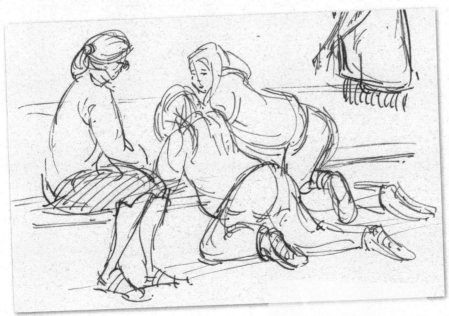

STAGING SHOWS RELATIONSHIPS

In this sketch, two of the characters seem more playful than the girl with the stiffer body language on the left. They all seem to be friends, but the two who are closer seem to be kindred spirits.

BUILDING A SCENE

As people crowd into public places, they interact with each other and the setting around them. Crowds aren't made up so much of separate individuals as they are of small groups. In an amusement park, for example, you wouldn't see people by themselves but with their friends or families. There would be clumps of people who interact within their group more than with surrounding groups. Internally, these groups contain individuals who play the roles of friend, lover, rival, authority figure or dependent. Each person has a role and a different relationship with other members of the ensemble, which has to be considered in your staging.

Even when strangers gather in temporary groups, shoved together by circumstances and forced to interact because of proximity, you find people in clumps and not evenly spaced. Interactions could be limited to a quick glance, a rebuffing posture or a friendly wave, but it's the relationships between people, no matter how cursory, that make the drawing interesting.

Whether you're drawing a single person in a scene, a small gathering or a large crowd that is constantly changing with a fluid parade of new characters and reactions, the approach is the same.

Although the task of capturing a dynamic scene may seem exponentially more difficult as the number of people increases, the skills in observational drawing, gesture drawing and figure construction are all that are needed to depict what's going on.

In every scene, no matter how active, the setting doesn't change. Walls don't move, lamps and tables stay put, and trees, although they may sway in the wind, don't get up and leave while you're drawing them as people often do.

SETTING THE STAGE

In a scene where the location is the focus, begin by developing the setting. Use your observational skills to plot out the scenery. Once you have set the stage, you can then add people as they come in and out of the setting.

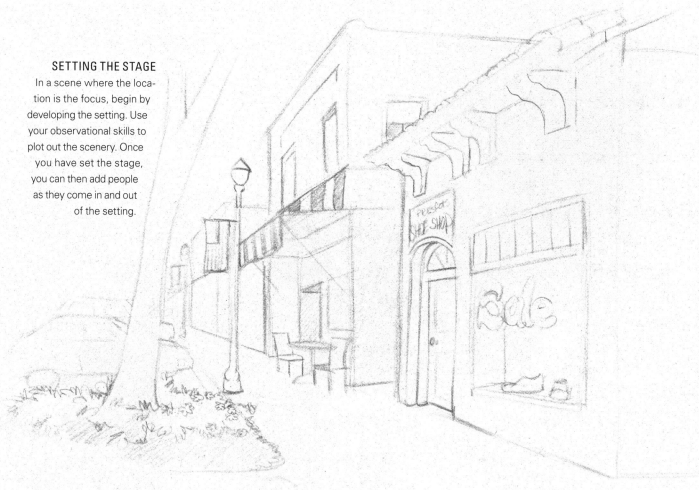

CREATING A SCENE

To make this a bit more clear, here are a few consistent steps you can use to create your scenes as you sketch.

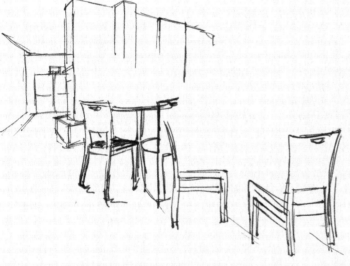

1| Develop the Setting

Begin the setting using the point-to-point technique. Compare heights, widths, angles and intersections of all the unmoving objects in a scene and plot them on the page.

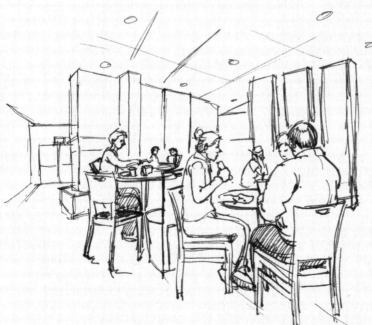

2| Add People

Once the basic setting elements are anchored, you will have a reliable reference to add people to the scene one by one. You won't be able to capture everything at once, but you can "grow" a scene by adding people individually until you have populated the whole setting.

When someone wanders into the scene, capture his or her gesture. Keep in mind the proportion you have already established by noticing where the person intersects two-dimensionally against the setting. Quickly and simply develop the figure's three-dimensional form and add the clothing. Then move on to the next person, continuing in this way until the setting is appropriately inhabited.

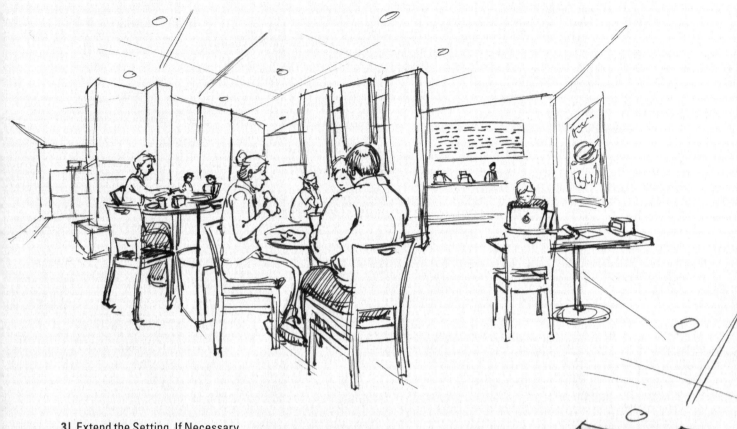

3| Extend the Setting, If Necessary

Of course, this process isn't always so linear. As you add more people, you may extend your setting to accommodate them. If the interaction of the people is what you want to record, you can start with the people and build the setting and other figures around them. There are no hard rules in drawing.

FINDING THE STORY

Your experiences are the key to finding a story. Don't discount your experiences because they don't seem grandiose or glamorous. Being afraid to call someone on the phone tells us a little about the battle between anxiety and desire. Being ignored by someone we want to connect with shows us how rejection and isolation feel. These private experiences are the seeds to connecting with other people who are feeling the same thing in a different situation.

4| Finish

You have the option to finish your sketches however you wish. You can use a toned wash as I've done here, or you can use crosshatching, watercolors or any other media to liven up the scene.

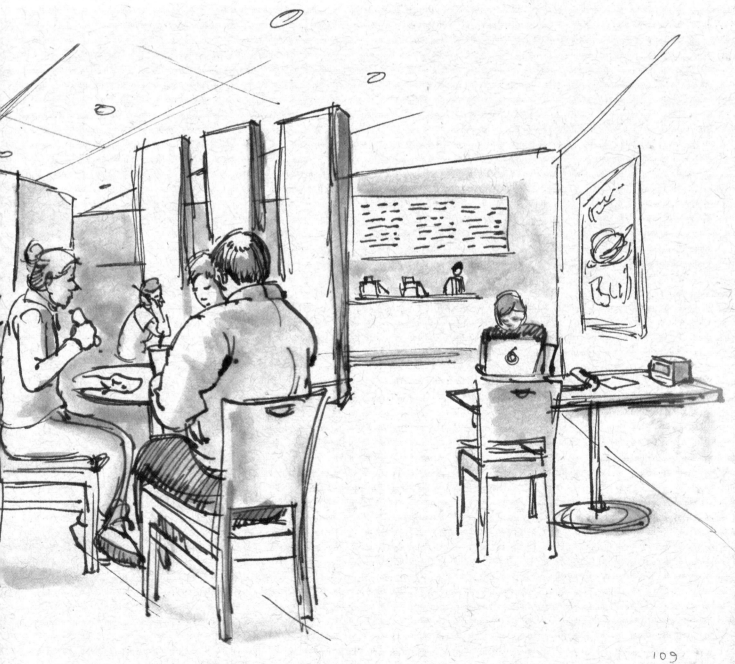

VALUE

Light's vibrant energy is what creates the subtle shades on a form for our eyes to see. Light can make anything beautiful when it illuminates an object's best qualities and hides its flaws in the mystery of shadow. As light plays into a scene, it takes on different characteristics and helps to create mood.

You can orchestrate the values to control the mood you want to create, and design the light and shadows to best convey your idea.

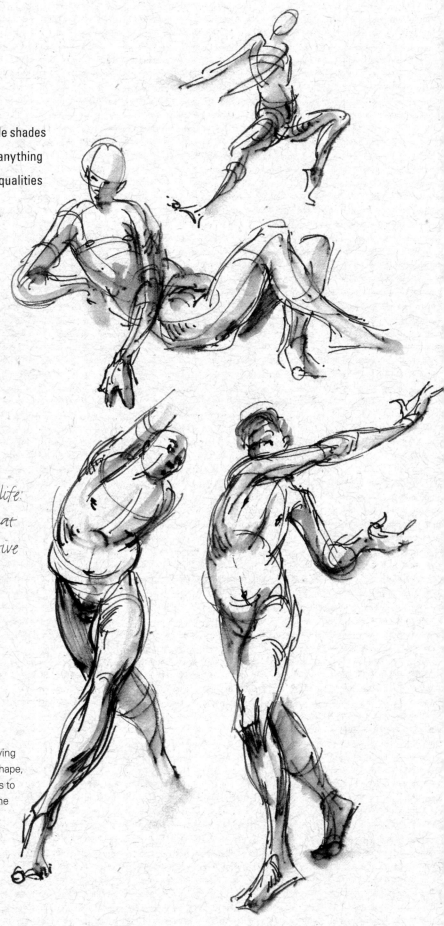

"I never saw an ugly thing in my life: for let the form of an object be what it may—light, shade, and perspective will always make it beautiful."
— John Constable

ADDING VALUE
Value adds interest to a drawing because it gives a sense of shape, form and light. Shading needs to be used logically to help define the three-dimensional forms.

VALUE & VOLUME

In order to effectively add value to a form, you really have to understand it three-dimensionally. Being able to break down a form into planes helps in figuring out what values should be used. Value strengthens the sense of volume because it shows how the surface of the form faces or turns away from the light source.

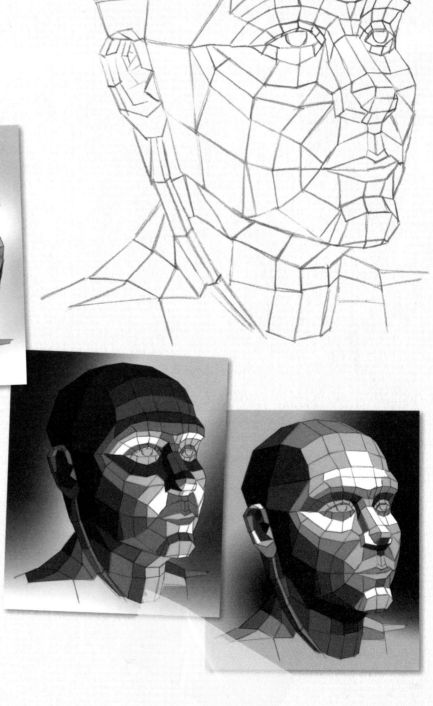

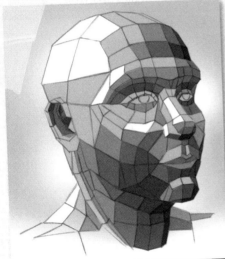

PLANES FACING LIGHT ARE WHITE

This head, reduced to simple planes, shows how light can play across a form. The planes make it easier to apply light and shade because they clearly show how a form turns away from the light. All planes that directly face the light are white, and they get darker the more they turn away. In the three examples above, I used Adobe Photoshop to apply light and shade to the pencil drawing. You can see how clearly the light gives the drawing a strong sense of volume.

LOCAL VALUE

Everything has an inherent level of lightness or darkness independent of the amount of illumination. For example, a dark blue shirt will always have a darker value than tan pants no matter how much light is flooding the scene. This is called *local value*. Local value is the idea that light is dispersed everywhere evenly. Without shadows, we're left with the value of the object as it is, rather than how it appears under the effect of a light source. You can see this at work in primitive and medieval art. These artists were concerned with capturing the object rather than how the object appeared in a particular lighting condition.

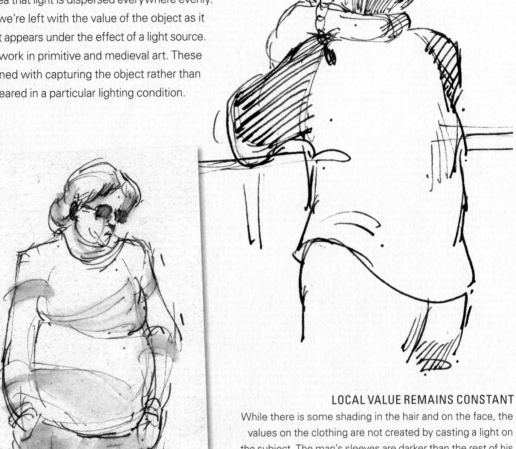

LOCAL VALUE REMAINS CONSTANT

While there is some shading in the hair and on the face, the values on the clothing are not created by casting a light on the subject. The man's sleeves are darker than the rest of his shirt, not because they are in shadow, but because the shirt was designed that way. Similarly, the woman's shirt has dark stripes and she wears dark pants.

MODELING LIGHT

As artists moved from medieval art and into the beginning of the Renaissance, the use of light in art began to change from local color to what I call *modeling light*. Modeling light defines form by assigning darker values for planes as they turn away from the viewer. A plane that faces the viewer is white but grows progressively darker in value as it turns away. This means that an outside contour line is black because the side plane faces away from the viewer at the greatest angle. It is almost as if the viewer is the light source.

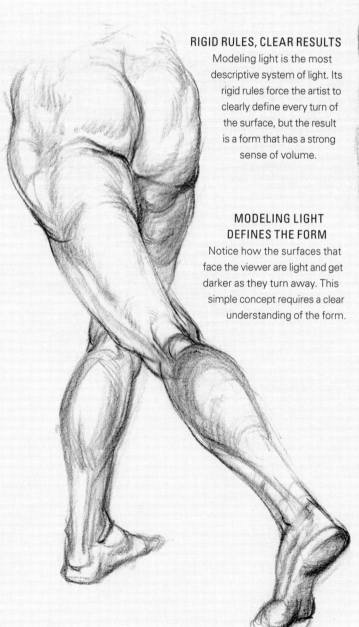

RIGID RULES, CLEAR RESULTS
Modeling light is the most descriptive system of light. Its rigid rules force the artist to clearly define every turn of the surface, but the result is a form that has a strong sense of volume.

MODELING LIGHT DEFINES THE FORM
Notice how the surfaces that face the viewer are light and get darker as they turn away. This simple concept requires a clear understanding of the form.

DIRECT LIGHT

This system of light is where there is a light source shining into a scene. This divides the form into two parts: the illuminated side that faces the light and the shadow side that is hidden from the light. The lightest part on the light side where a light source is directly reflected is the highlight. The transition value between the light side and the shadow area is the halftone. The shadow area would be totally black if it was completely devoid of light, but as the light bounces off surrounding illuminated areas, reflected light helps define the dark side of the form.

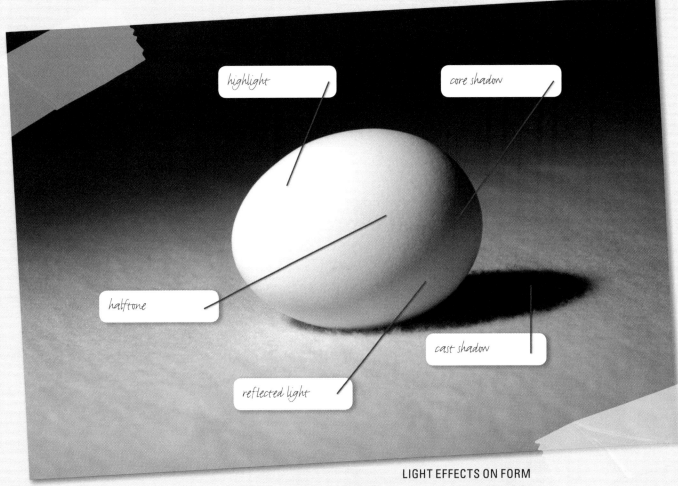

highlight

core shadow

halftone

reflected light

cast shadow

LIGHT EFFECTS ON FORM
This photograph shows how a direct light source illuminates a form. You can see that the light source is to your left.

LIGHT EFFECTS ON A HEAD

You can apply what you know about light on an egg to the
way light affects the appearance of the human form.

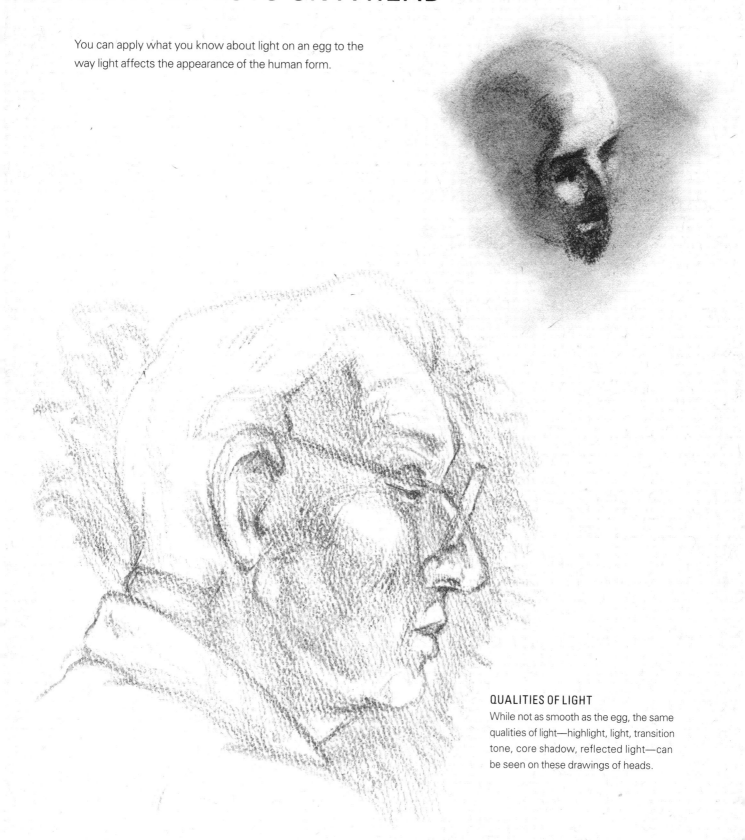

QUALITIES OF LIGHT
While not as smooth as the egg, the same
qualities of light—highlight, light, transition
tone, core shadow, reflected light—can
be seen on these drawings of heads.

LIGHT & SHADOW SIDES

Light divides the form into two sides, light and shadow.

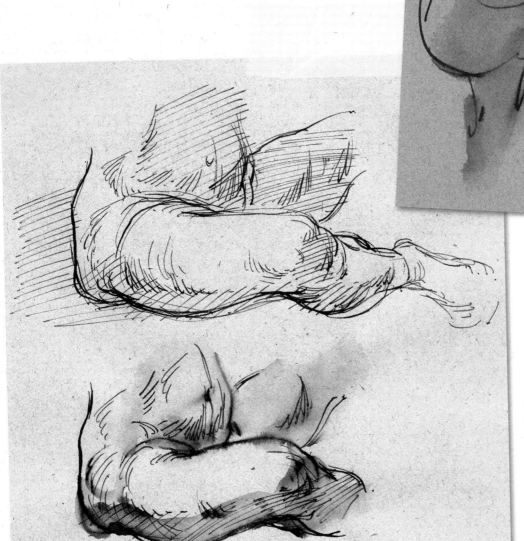

A SIMPLE SWATH OF TONE

A simple swath of tone is an easy way to give a sense of the light in a quick sketch, but does little to develop the drawing's three-dimensional qualities.

SHADOW WASH

While the shadow wash is fairly flat on, when layered over crosshatching the figure retains its volumes. This is a quick way to develop lighting when quickly sketching people.

UNIFYING VALUES

When composing an image, whether a solitary figure or a complete composition, the overall values need to be grouped and simplified. Light and dark areas should cluster together, creating large areas rather than having a patchwork of small spots of shadows and highlights.

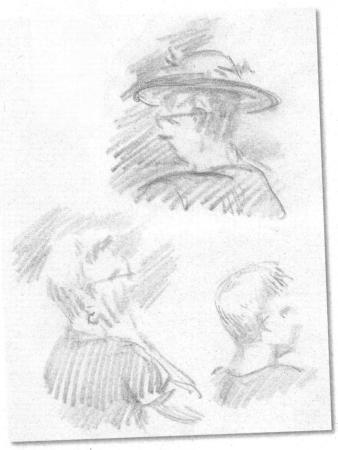

SHADOW AREAS
By only drawing the shadow areas and leaving the light areas blank, the unified dark and light areas create the image.

BLACK AND WHITE
In this drawing, the values have been limited to black and white to define the overall pattern of the shadow areas and the light areas. The dark areas are large masses rather than spots here and there.

COMPRESSING VALUES

Once the light and dark areas have been designed, a value range for each needs to be determined. If most of the image is in the light area, most of your values will be used in that area—say, white through 70 percent black. This leaves only 30 percent of the total value range to be used exclusively in the shadow areas.

This asymmetrical balance is called *compressing the values*. Avoid dividing the value range into two equal halves with 50 percent in the light and 50 percent in the shadow areas because it lessens the drama the values can convey.

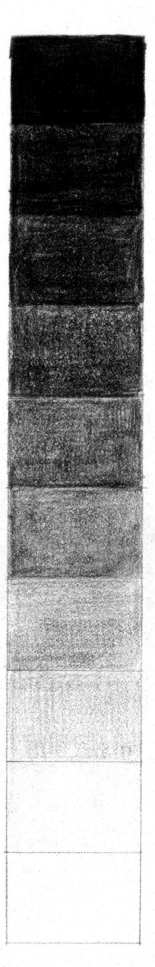

VALUE SCALES
Practice making value scales that go from your whitest white to darkest dark.

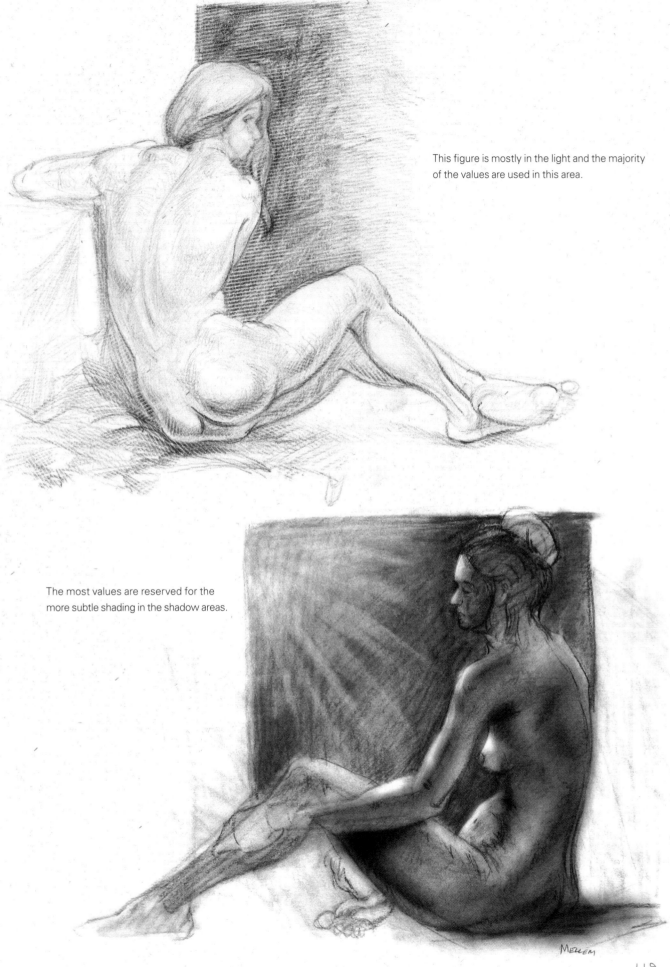

This figure is mostly in the light and the majority of the values are used in this area.

The most values are reserved for the more subtle shading in the shadow areas.

MELLEM

119

CONCLUSION: ON CREATIVITY

Some people believe that creativity is like magic, that it is a mysterious force that reveals itself to the lucky few. This couldn't be further from the truth. Creativity comes to those who have nurtured the traits that encourage inspiration.

1| Curiosity. Creative people wonder what makes something work and why. Why people act the way they do. Why the world is this way and not that way. Curious people innately seek out new experiences that add to their knowledge, giving them the raw material to create ideas.

2| Having fun. Creative people also have fun. They play. They use objects as they weren't intended and make up games just for their pleasure. They joke around, break the rules and draw outside the lines. Playfulness encourages the mind to find connections between things that seem dissimilar. This blending of ideas is the engine of creativity, and it's powered by fun.

3| Optimism. Creative people are optimistic. They aren't critical because criticism kills emerging ideas as well as all the fun. They never say "no" to an idea, they just play around until they find a better one. They enjoy the energy of discovery and the prospect of new ideas.

4| Courage. Creative people are courageous. They dare to question the status quo. They risk rejection from people who are afraid to see things in a new way. They risk embarrassment by championing an idea that may not ultimately work. They do something when it is easier to do nothing.

Understanding the traits of creative people also tells us what to do if we can't seem to find any ideas. If the problem is that you keep repeating the same idea, nurture your creativity and seek out new experiences to expand your knowledge. If you've studied your topic and can't find a new idea, play around with it and see how some of those ideas might connect with something entirely different. If you still can't find what you're looking for, wait. Put it out of your mind for a while. If you've explored the idea well enough, you will have a lot of "hooks" out that will snag on any new experience that brushes by and you will be blessed with an "Aha!" moment.

Creativity isn't a step-by-step procedure like learning a technique—it's more organic. Sometimes you have a clear idea of the concept you want to express, but often you will discover it as you're working and refine the idea through successive revisions. The creative process is reciprocal: You act to create but you also react to what you're creating. Your work will help you discover new things as you think through the problem. That is the process of idea making.

Topics can be approached in an infinite number of ways, and your tastes, skills and experiences will help you decide how to best communicate your thoughts. The final step in the creative process is deciding which idea to pursue. Creating a hundred ideas isn't as hard as choosing one to spend time developing and letting go of the other ninety-nine. The key to the answer is in the question. You have to figure out which idea best fulfills the goals you want to accomplish.

Get out your sketchbooks and start creating!

RECOMMENDED BOOKS

Below is a list of recommended books. In addition, I recommend any book of sketches by a famous artist whose skill you appreciate.

VILPPU DRAWING MANUAL
BY GLENN VILPPU

One of the best books on basic figure drawing.

(1997 Vilppu Studio)

BRIDGMAN'S COMPLETE GUIDE TO DRAWING FROM LIFE
BY GEORGE B. BRIDGMAN

A classic text on intermediate to advanced figure drawing.

(2002 Sterling)

STRENGTH TRAINING ANATOMY
BY FREDERIC DELAVIER

Designed for bodybuilders to learn basic anatomy, but is a great reference for muscles in motion.

(2005 Human Kinetics Publishers)

HUMAN ANATOMY FOR ARTISTS: THE ELEMENTS OF FORM
BY ELIOT GOLDFINGER

An in-depth book on anatomy.

(1991 Oxford University Press)

THE ILLUSION OF LIFE: DISNEY ANIMATION
BY FRANK THOMAS AND OLLIE JOHNSTON

Written by two of the greatest Disney animators of all time, the book is both a history of the studio and an instructional guide to getting life and attitude into your drawings.

(1995 Disney Editions)

FIRST STEPS: PAINTING WATERCOLORS
BY CATHY JOHNSON

Watercolor is one of the easiest ways to get color into your sketchbook because it is so portable, and this book is an excellent guide that seems tailor-made for sketchbook painting.

(1995 North Light Books)

AFRICA: AN ARTIST'S JOURNAL
BY KIM DONALDSON

A beautiful and inspiring book that demonstrates the sketchbook as a work of art in its own right.

(2002 Watson-Guptill)

DINOTOPIA: A LAND APART FROM TIME
BY JAMES GURNEY

This is a children's book that is illustrated as if it were a sketchbook kept by adventurers going through a fantasy world. It is a great example of a how a sketchbook can tell a story.

(1992 Turner Publishing)

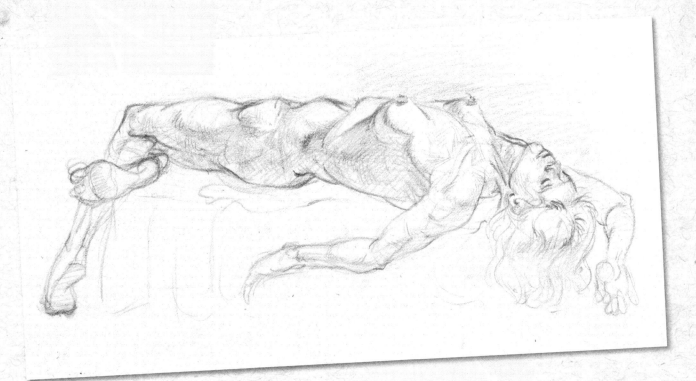

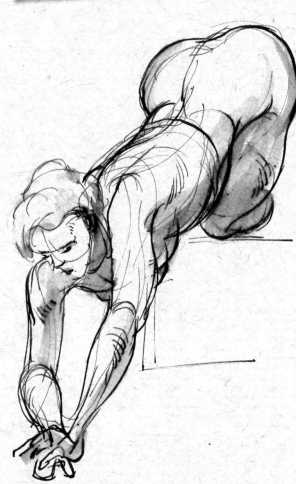

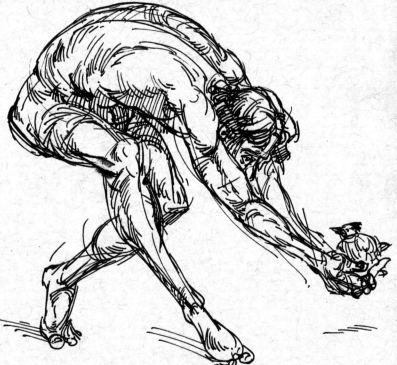

GALLERY

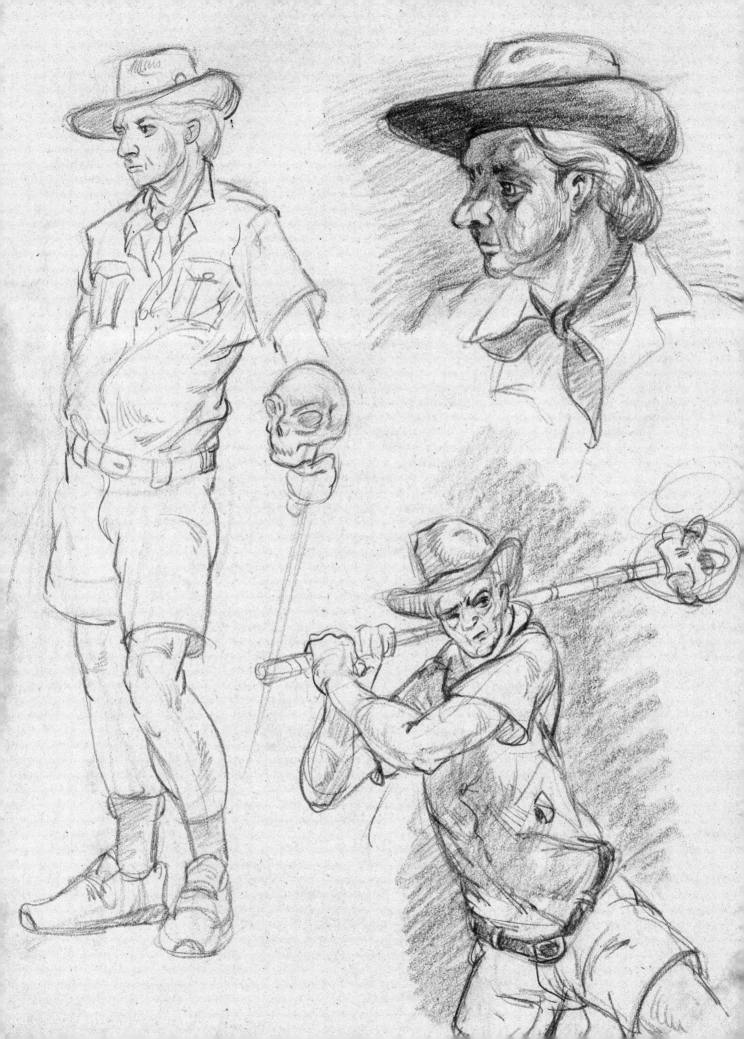

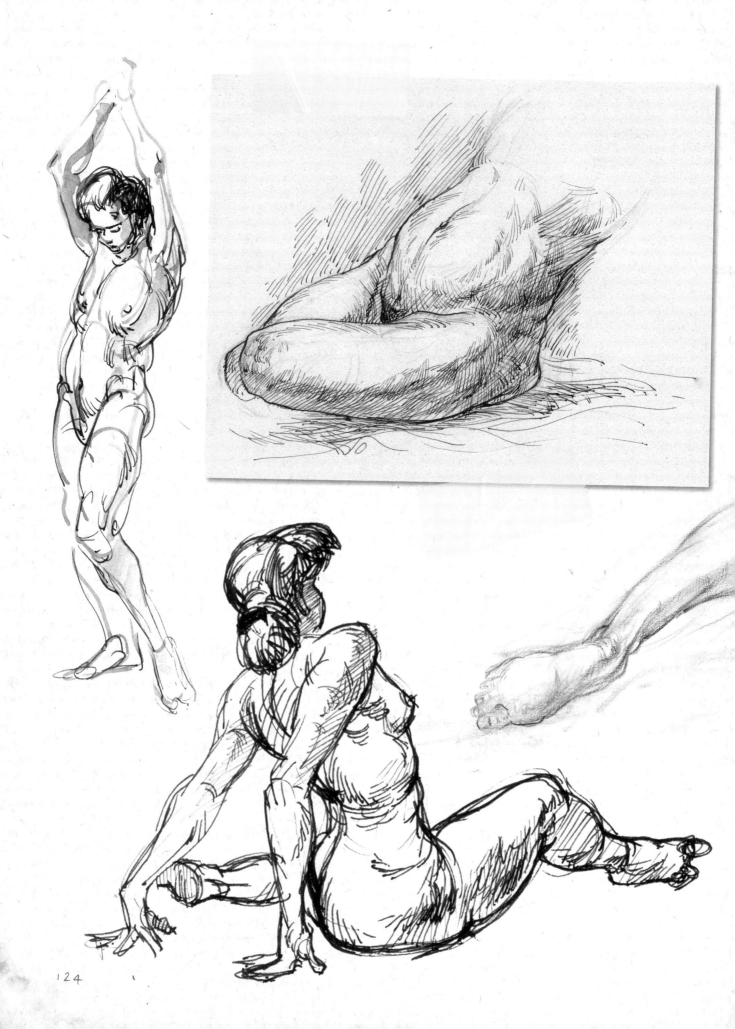

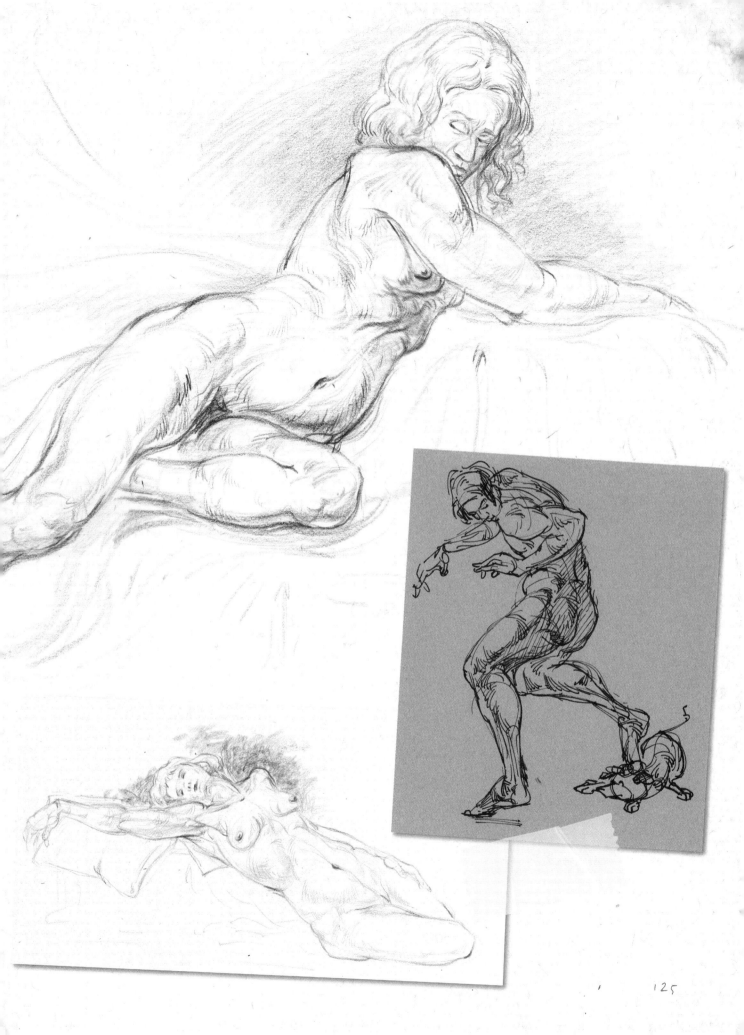

125

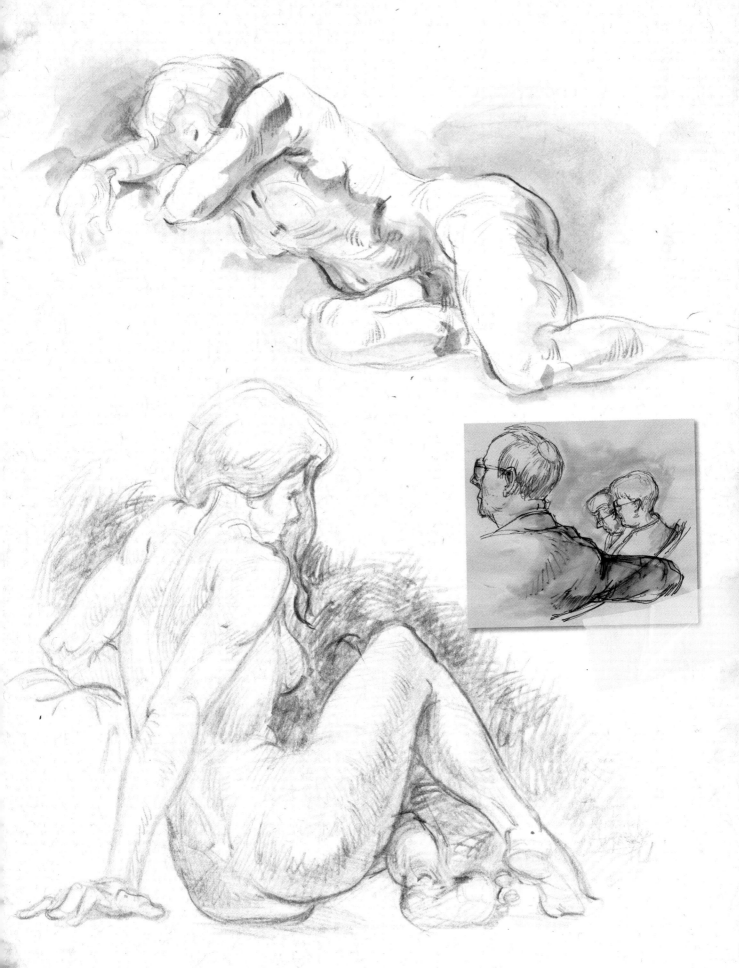

INDEX